HIRSCHFELD

by

HIRSCHFELD

Introduction by John Russell

DODD, MEAD & COMPANY / New York

With few exceptions, these drawings first appeared in the
Weekend and Sunday editions of *The New York Times*. I am
grateful to the proprietors of that paper for permission
to reprint them in this book.

Library of Congress Cataloging in Publication Data

Hirschfeld, Albert.
 Hirschfeld by Hirschfeld.

 1. Entertainers — Caricatures and cartoons.
2. American wit and humor, Pictorial. I. Title.
NC1429. H527A4 1979 741.5′973 79-17023
ISBN 0-396-07777-3

To Dolly's sister, Margaret, with love

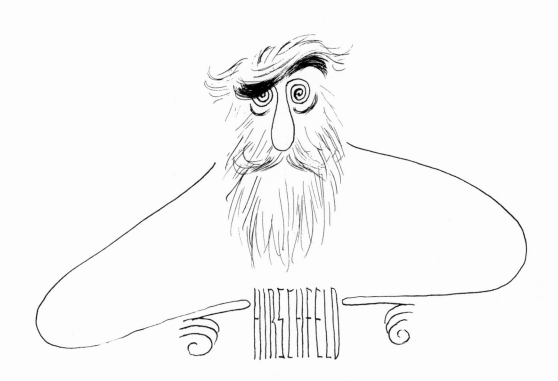

Introduction
by John Russell

Al Hirschfeld is the complete draftsman. He can draw anyone, anywhere, at any time. He can draw in the daylight, like everyone else, and he can draw in the dark. He can draw people singly and severally, and he can draw them in tumultuous conjunctions of the kind at which George Cruikshank excelled in England in the nineteenth century. He can draw them in close-up, with no indication as to where they may be or where they have come from, and he can draw them in their habitual environment, with every brick and every last windowpane in place. He can draw them still and silent, and he can draw them in the violence of action. And he does it with a sovereign economy: never a line too many or a piece of evidence that we could have inferred for ourselves.

His fifty-years' bondage to Broadway has kept much of this a secret even from those who most look forward to his drawings. That he is a great theater-man goes without saying: few men can have sat through so many terrible entertainments with so little complaint. But as a big-city man, in a more general sense, he is in a very high class. He has it in him to take any given metropolitan society and document its every detail. He could have been the scourge of the unworthy, like his friend George Grosz. He could have trodden lightly: a Fred Astaire of pen and ink. He is as interested in the outdoors as in the indoors of a great city, and it is a matter merely of professional accident that he got locked into the theater just over fifty years ago and has never been let out again.

The theater knew what it was doing, of course, and so did the successive editors who have kept him pinned, year after year, to the monumental barber's chair (built, by the way, in his native city of St. Louis) in which he gets his drawings ready for the printer. Al Hirschfeld is the most observant of men, but he has the gift of human charity. The entertainments that he goes to see are failures, more often than not. For the people who appear in them, they mean an exposure that is most probably brief and quite possibly calamitous. There is no player, no matter how distinguished, who has not foundered more than once in some misbegotten venture. Players are by their very nature impetuous, gullible and eager to work. A vindictive ax-man could do them mortal damage if he recorded their failings, day in and day out, for half a century.

That has never been Hirschfeld's way. Ever since 1925, when he made a drawing called "Weber and Fields revive their celebrated act from Burlesque for 'The Lambs Gambol,'" he has been giving performers the benefit of the doubt. If they were terrific, he told exactly how and why. If they weren't so great, he didn't let on. (If they were already in the Hall of Fame that did not exempt them, by the way, from the same careful scrutiny that they had survived as beginners.) He has no formulas, either, and for that reason he has never been overtaken and rendered obsolete by a new generation of players and new fashions in performance. What he draws may age, but the drawings themselves remain remarkably fresh.

This is not to say that he does not, like the rest of us, have preferences that came to him in youth and have never gone away. I fancy that he enjoys most what the French call "the consecrated monsters" of the theater: actors and actresses who are larger than life and don't let us forget it. If an actor "carries on like the guy next door" Hirschfeld will extend to him a scrupulous fairness; but if pressed he will admit to preferring what he calls "the glandular actors" — people like the Barrymores, like Orson Welles, and like Zero Mostel, who had only to step on to the stage for us to sit forward in our seats. It is to an actor of that sort, Sacha Guitry, that he owes his debut as a theater-draftsman; if he had not seen Guitry on the stage in New York and been inspired to put his impressions on paper then and there, he would not have been asked to make a fair copy of the drawing for possible use in print, and Broadway would have lost its longest-running archivist and most discerning historian.

But somehow, somewhere, he would have gone on drawing, for as an eight-year-old boy in St. Louis, he had decided that drawing was the most fun thing that there was. He grew up at a time when people took it for granted that newspapers and magazines would be full of handmade images. A generation earlier, John Sloan and Robert Henri and Mark Tobey and Alexander Calder had been delighted to make drawings to order for immediate publication, just as Winslow Homer had once been delighted to work for "Harper's Magazine." In the 1920s and 1930s there was always work for a draftsman who could turn his hand to whatever was wanted and would be ready on time.

It was not a disreputable activity, either. It had been good enough for Honoré Daumier. It had been good enough for Constantin Guys when the *Illustrated London News* took him on. It had been good enough for Charles Keene and Forain and Steinlen. It had been good enough for Juan Gris when he first arrived in Paris. In every great city in Europe there had been draftsmen who worked for the periodical press and enjoyed it; and many of them have lasted better than the academicians who looked down on them in their lifetime. History tends to look kindly, even if contemporaries do not, on the honest journeymen who rolled up their sleeves and kneaded the dough of life while others were wondering how best to recycle "The Oath of the Horatii" or "The Death of Ophelia."

Not that the options of high art were not open to Al Hirschfeld when he was a young man. Arriving in Paris in 1924 (dressed in the striped trousers and cutaway coat which his father thought appropriate for a first visit to Europe) he did what was expected of an aspiring young artist. He took a studio. He spent time with other young painters. He experimented with sculpture. He went south in the winter — not merely to the Midi, but to North Africa — and in 1925 he had a first show at the Newhouse Galleries in New York. He found out what he could do best. From his experience in North Africa, and from later forays in the Far East, he realized that he was by nature a line-man and not a colorist. The landscape that appealed to him was one in which color was bleached out — neutralized, almost, by the sun — and only line and shadow were left. (Balinese drawings pleased him in particular, with their El Greco-like line that served rather to distort than to caricature.)

Fifty years earlier he might have settled for a wandering, cosmopolitan life and supported himself with paintings and drawings, books and engravings, of the kind that made a good living for many a distinguished European artist. Like his old friend and sometime colleague S.J. Perelman, he enjoys a commissioned journey and knows how to make the most of it. Even within the boundaries of a single city he can give us the impression that we have crossed the world: witness "Manhattan Oases," a book on the state of the New York speakeasy to which he contributed drawings in 1932. Given that a speakeasy was by definition discreet to the point of clandestinity, we may marvel at the variety of places, and of clienteles, that Al Hirschfeld was able to set before the reader.

But he was too late, fundamentally, for the illustrated book, just as he was too early for the great boom in original prints. Hirschfeld as it happens is a very good lithographer. Faced with a glutton in New York, a scene of genteel poverty outside the British Museum in London, or the seduction of a pre-1939 night-place in Paris called "The Sphinx," he could come up with something that belongs to social history and not at all to cartooning. But prints of that kind did not pay the rent in the 1930s: and meanwhile he had already been for ten years or so in receipt of a weekly telegram from *The New York*

Times. Could he do a drawing of such-and-such a person to fit such-and-such a space "by Tuesday at latest"? He did, and he's still doing it, and it never looks stale.

He has, in fact, lasted better than Broadway itself. Looking at his drawings of a Broadway opening twenty years ago, we wonder at the white ties, the top hats, the conspicuous jewelry, the fur coats that would stifle a gorilla. Such things bespeak an era in which Broadway was still an untroubled republic. People trod safely along clean streets, and a Broadway opening stood high in the hierarchies of creativity. That the theater had glamor was conceded even by those who never went there. Not to have been in the house when the best play of the season had its premiere was a reverse from which people took weeks to recover. To put on your best clothes and go down to Broadway was a classic evening out, and one to which almost everyone looked forward. The whole town was Broadway-oriented, in those days, and Broadway gave off self-confidence the way a fire hydrant gives off water.

Hirschfeld knew that theater as well as anyone. His little book, "Show Business Is No Business," which came out in 1951, is our best brief manual of instruction as to how it worked, who ran it, and who got run out of it. Hirschfeld knew the theaters, the owners, the lessees, the producers, the directors, the authors, the actors, the actresses, the backers and the hangers-on. He knew the tryout circuit, city by city; and as the coauthor of a famously unsuccessful musical (in which his colleagues were Ogden Nash, S.J. Perelman and Vernon Duke) he knew the process of production from start to finish. When he drew, he drew not only as an experienced and intelligent observer, but as a participant and a survivor.

In general, as I said earlier, he has no trouble moving with the times. Besides, the theater that he most enjoys is the kind that will last as long as the idea of acting itself: an evening in which greatly talented people go all out from start to finish. But I think that, other things being equal, he likes to see a lot of people on the stage. I also think that he likes to see an elaborate production of the kind that Oliver Smith and Boris Aronson are very good at. These are uneconomical tastes, but they are the ones that he grew up with. They are also tastes that made for great theater once upon a time in England, in France, all over central Europe, and in Russia.

But he will black all that out, if he has to, without repining. If the stage is pretty well bare and the cast numbers three, two, or even one, he will none the less make of his drawing a full-scale production. No one knows better than he when to draw like a Japanese swordsman, on the one hand, and when to touch in one telling detail after another. He can make us tell tweed from broadcloth, mink from sable, and a clip-on bow-tie from one that is made by hand. His black inks can look blacker than black, and he can make the untouched white of the page work for him as a henchman and a friend. He has no favorites: in a big cast, every man and every woman is drawn with equal care. And he does it with an evident pleasure that makes the reader want to go right out and buy tickets. He is an enjoyer, not a destroyer, and his every drawing suggests that the theater can still be what it ought to be: a school of human understanding. To have done that for more than fifty years is a very great service to the life of our city.

John Russell writes on art and on many other subjects for The New York Times, *and was for several years a drama critic in London.*

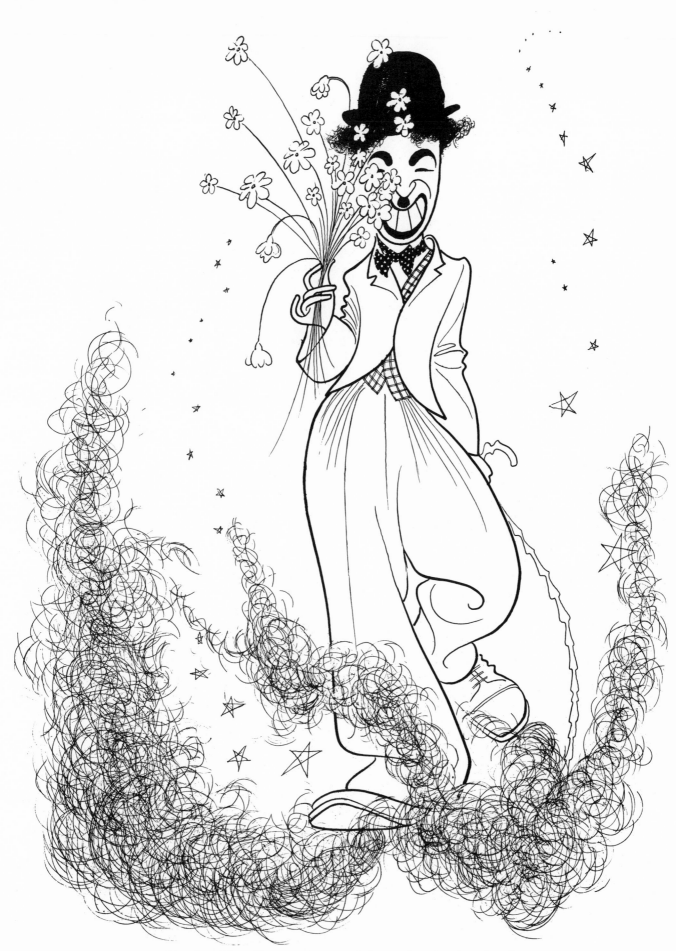

Charles Chaplin, genius with both feet in the clouds

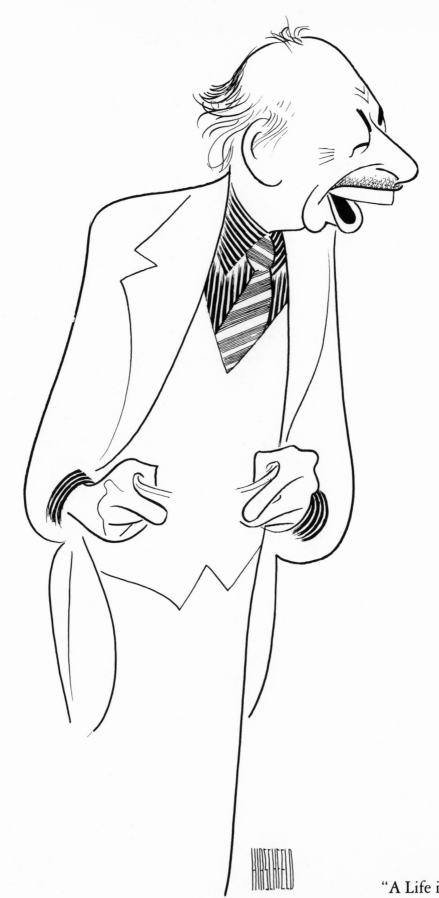

José Ferrer in
"A Life in the Theater"

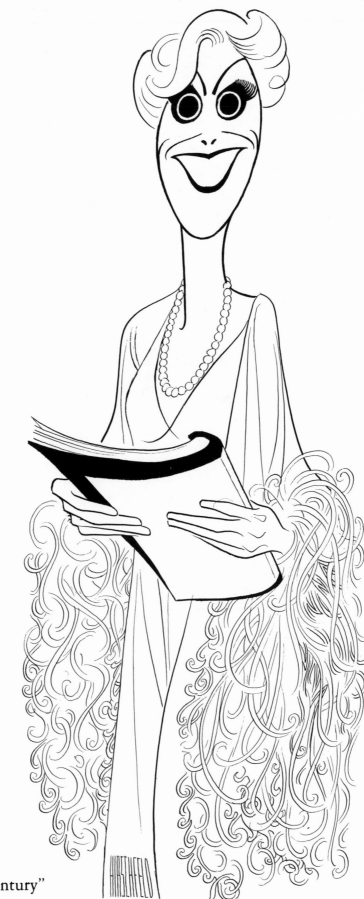

Judy Kaye in
"On the Twentieth Century"

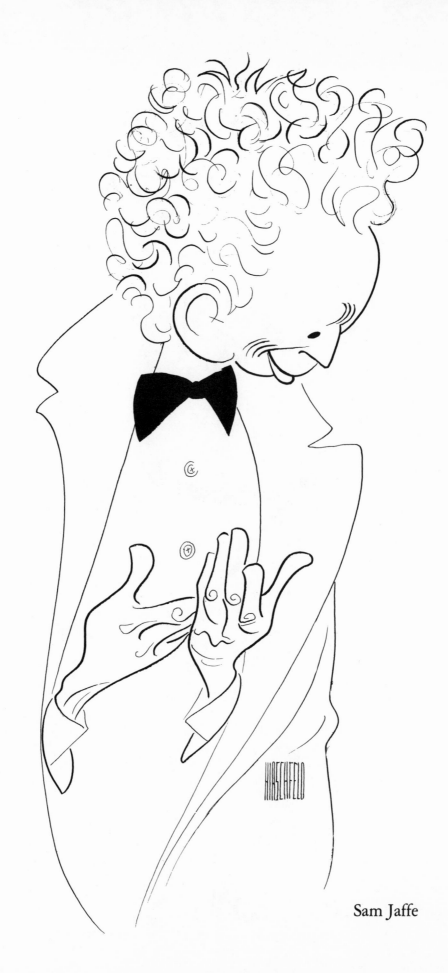

Sam Jaffe

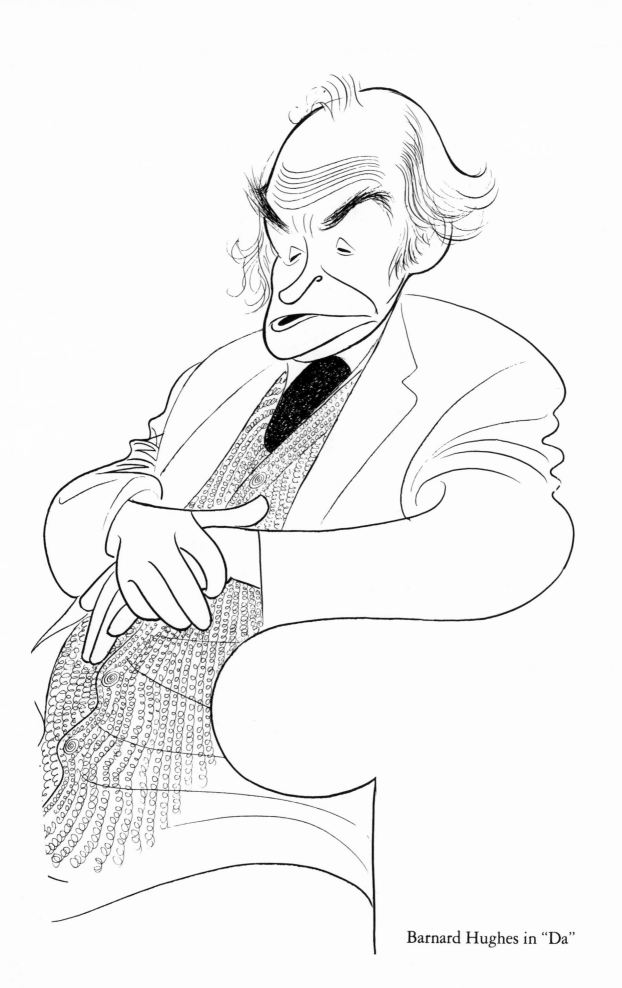

Barnard Hughes in "Da"

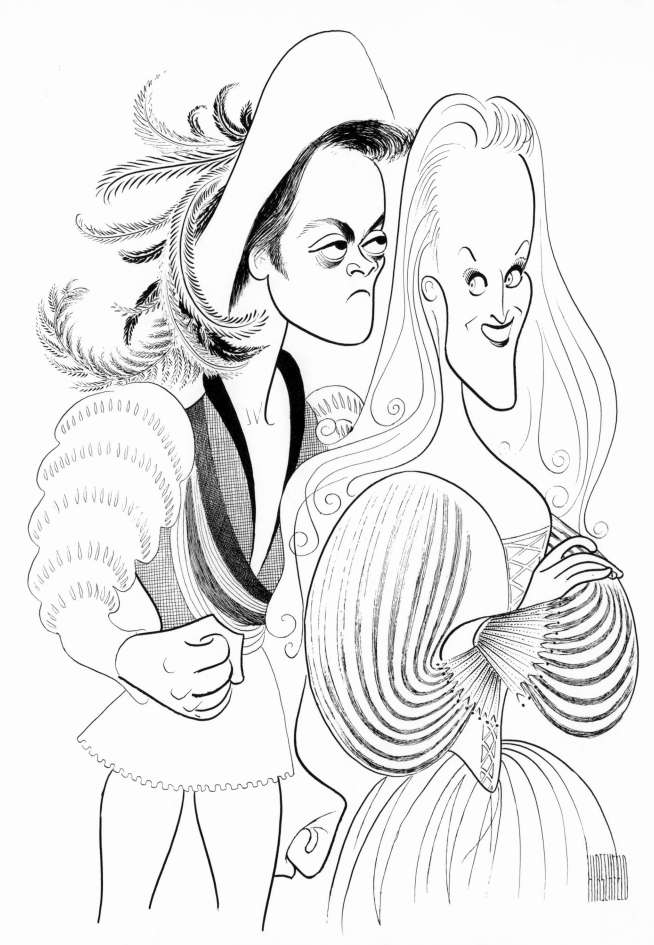

Raul Julia and Meryl Streep in "The Taming of the Shrew"

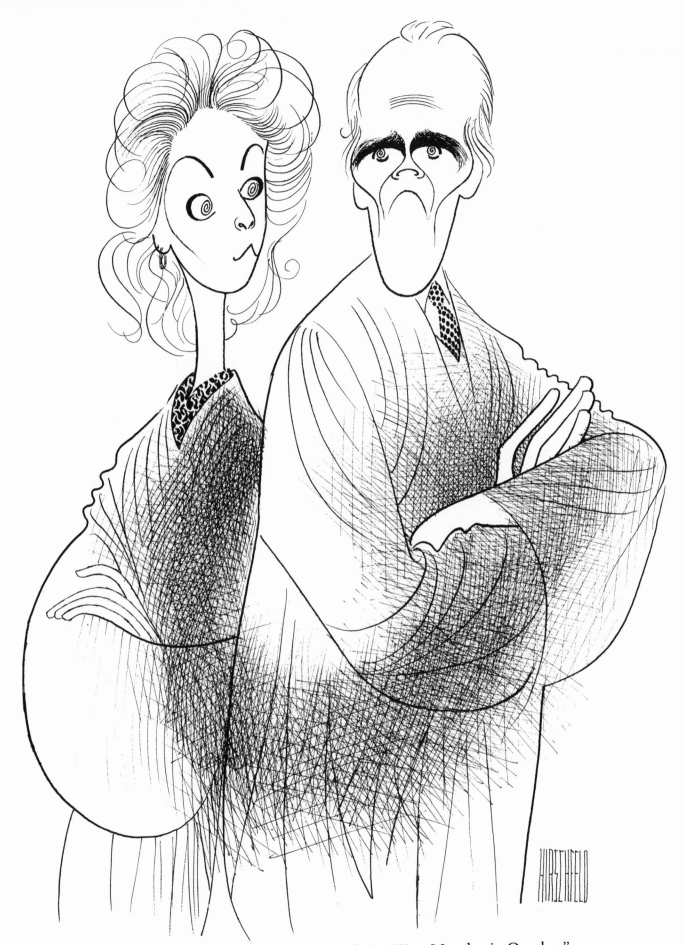

Jane Alexander and Henry Fonda in "First Monday in October"

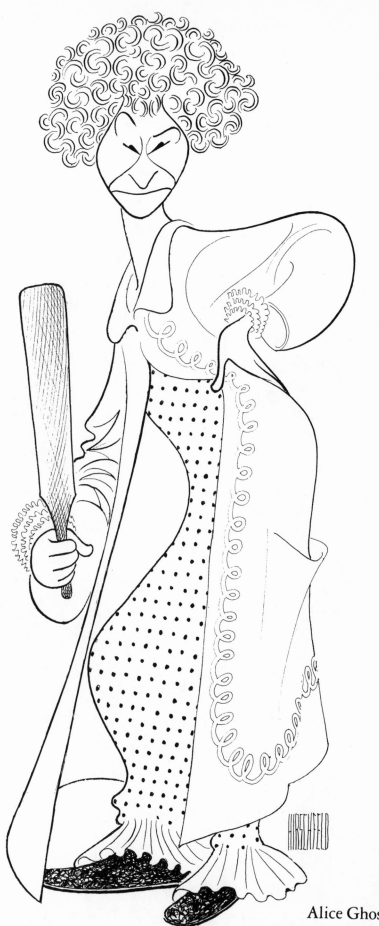

Alice Ghostley in "Annie"

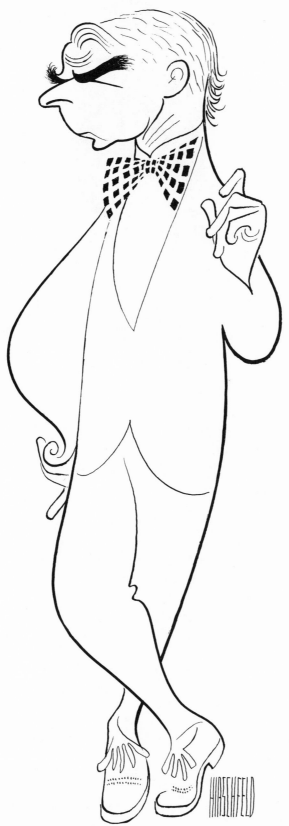

Emlyn Williams in
"The Playboy of the Weekend World"

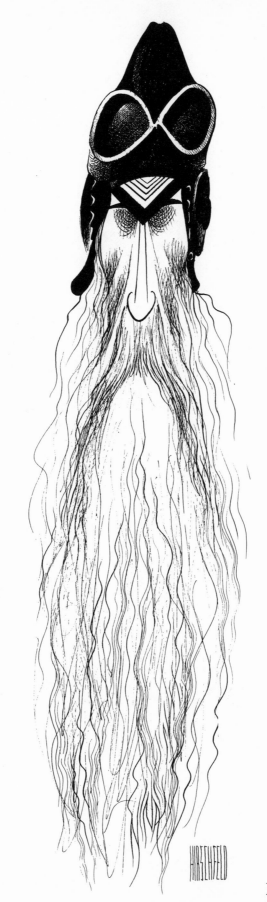

Rip Torn in "Seduced"

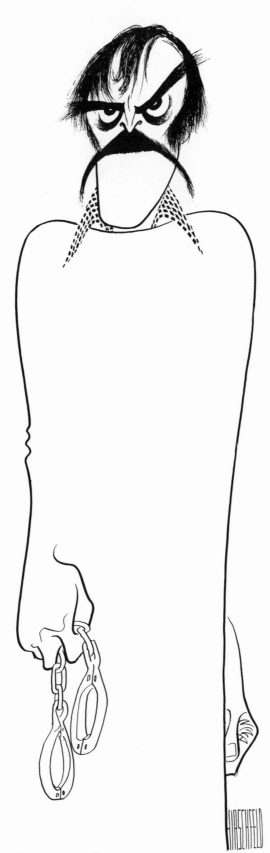

Stacy Keach in "Deathtrap"

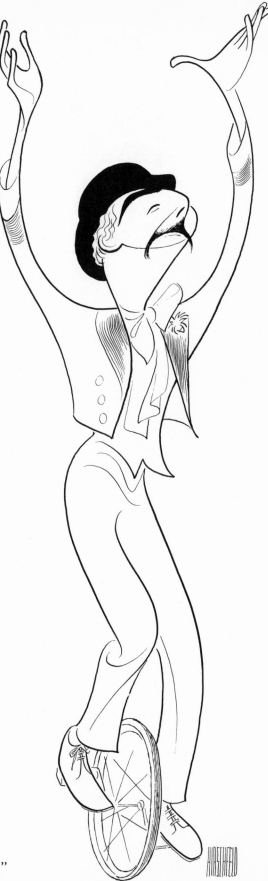

Joseph Maher in "Spokesong"

Edward James Olmos in "Zoot Suit"

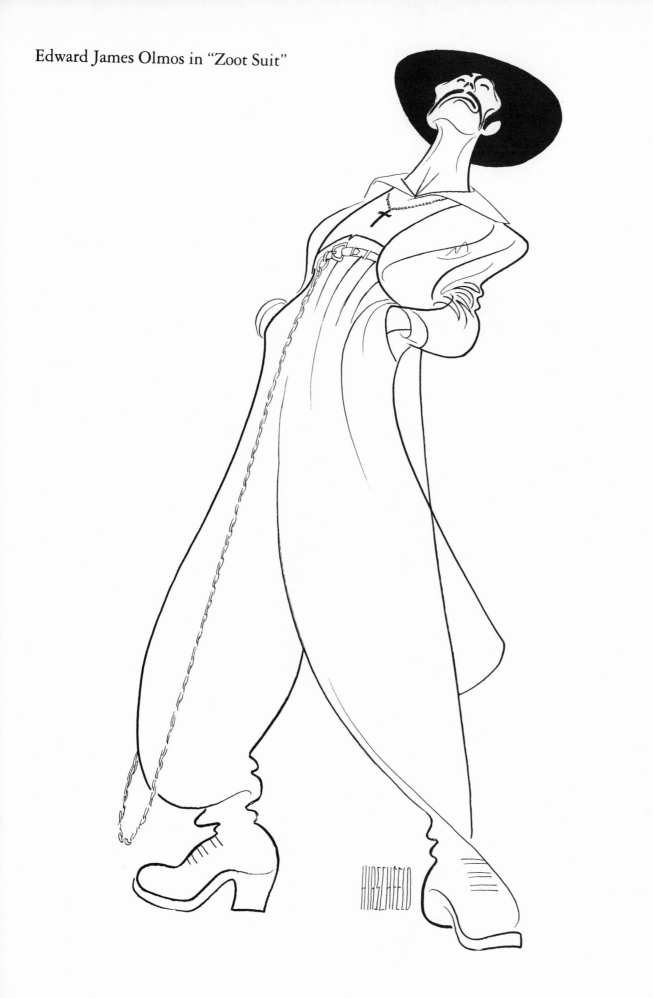

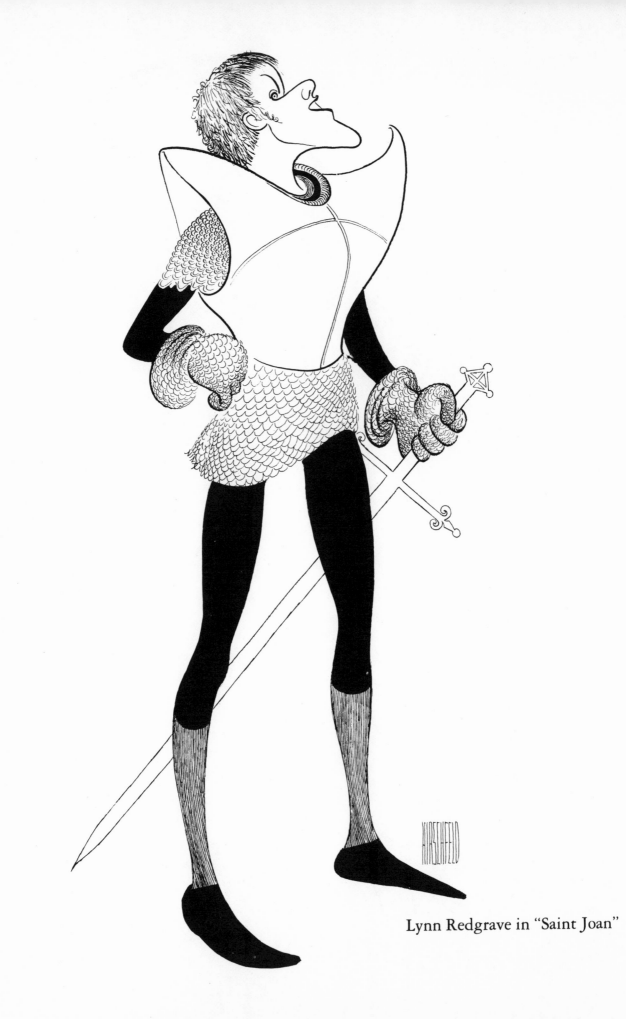

Lynn Redgrave in "Saint Joan"

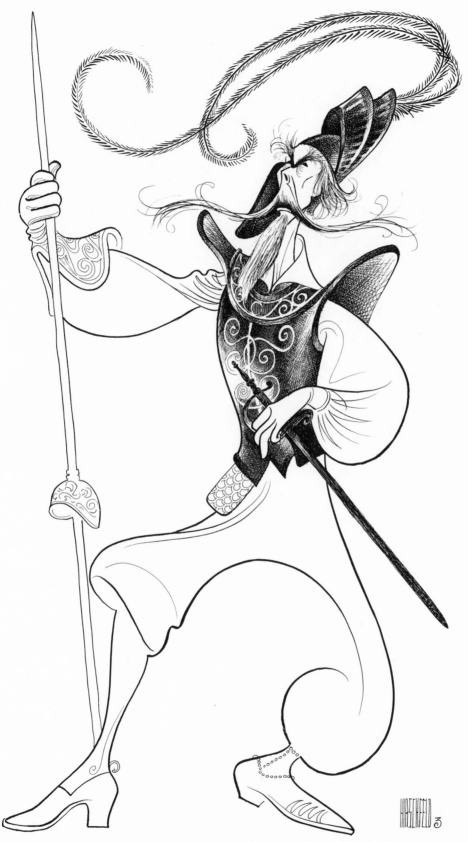

Richard Kiley in "Man of La Mancha"

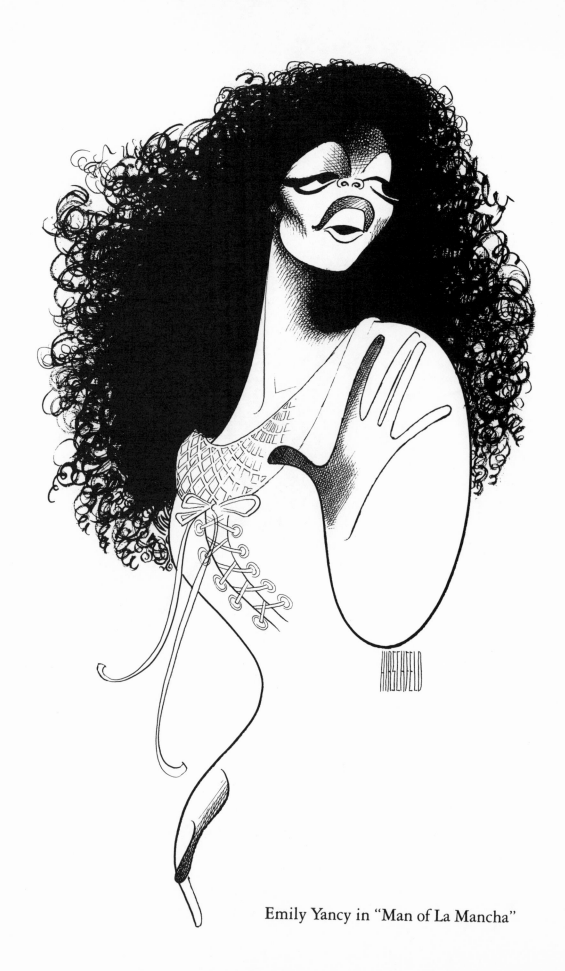

Emily Yancy in "Man of La Mancha"

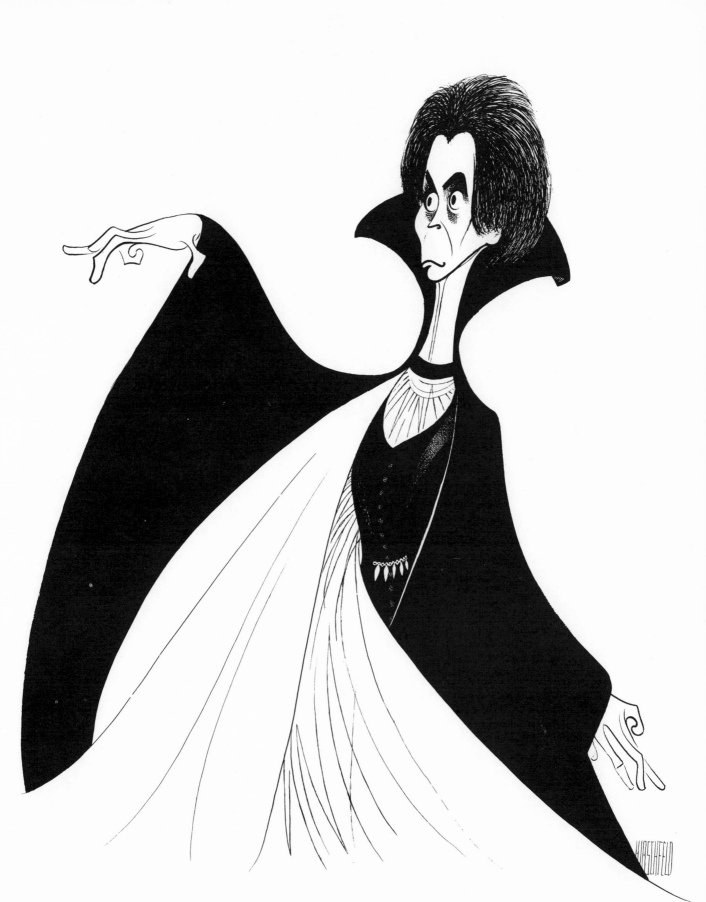

Frank Langella in "Dracula"

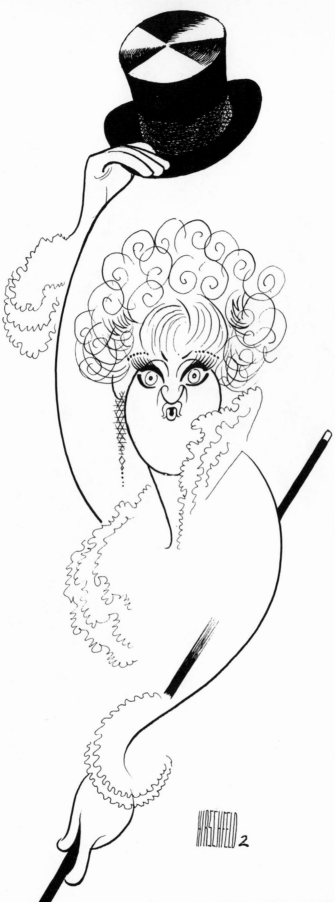

Hermione Gingold in "Side by Side by Sondheim"

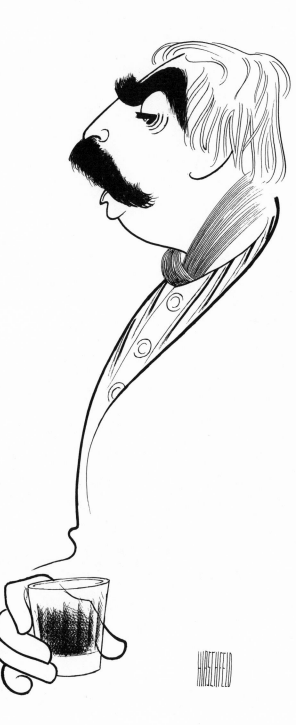

Milo O'Shea in "A Touch of the Poet"

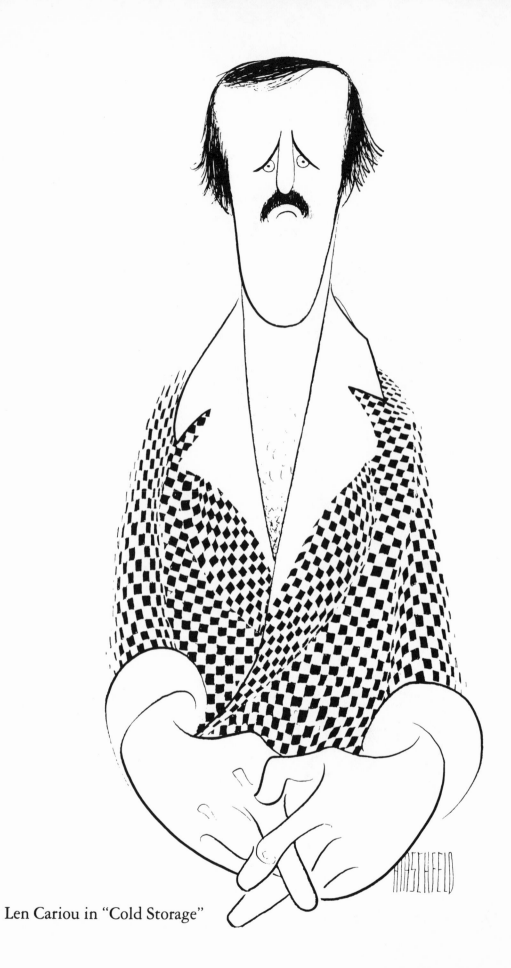

Len Cariou in "Cold Storage"

Jack Weston in "Cheaters"

Carol Kane in "The Effect
of Gamma Rays on Man-
in-the-Moon Marigolds"

Tammy Grimes in "Molly"

Kurt Kasznar in "The Play's the Thing"

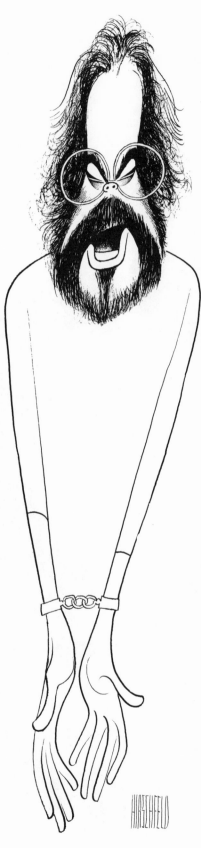

Laurence Luckinbill
in "A Prayer for My Daughter"

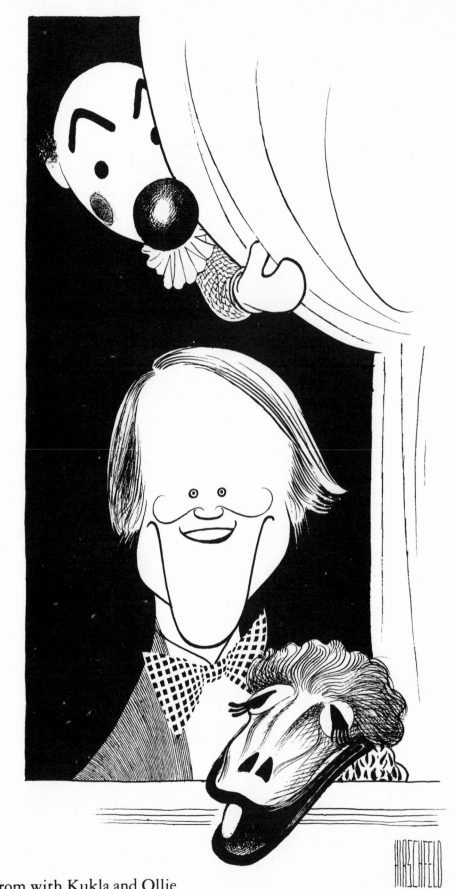

Burr Tillstrom with Kukla and Ollie

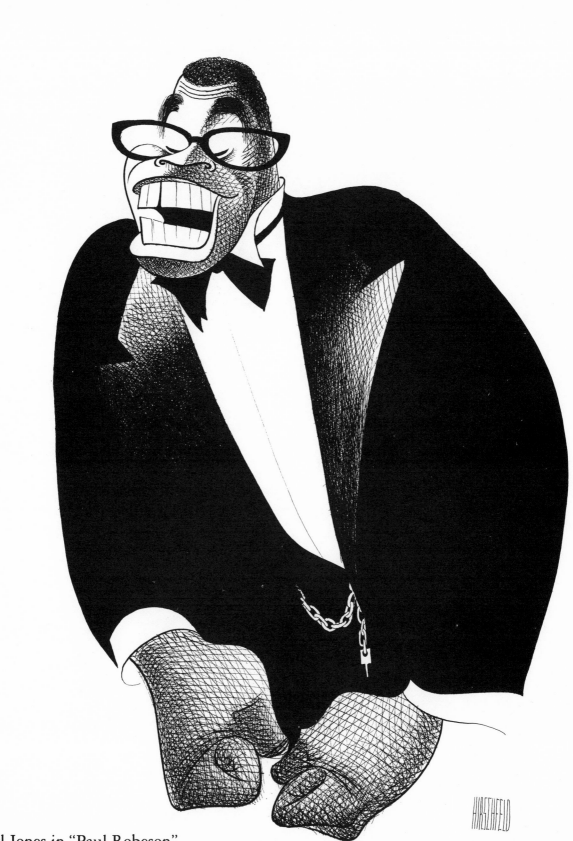

James Earl Jones in "Paul Robeson"

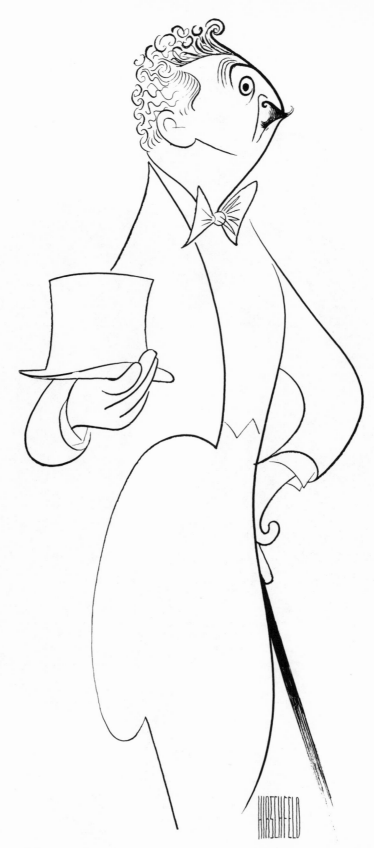

Eddie Bracken in "Hello, Dolly!"

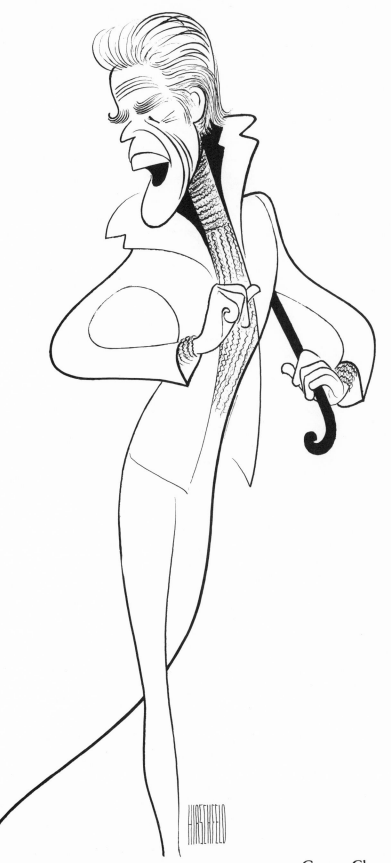

Gower Champion in "The Act"

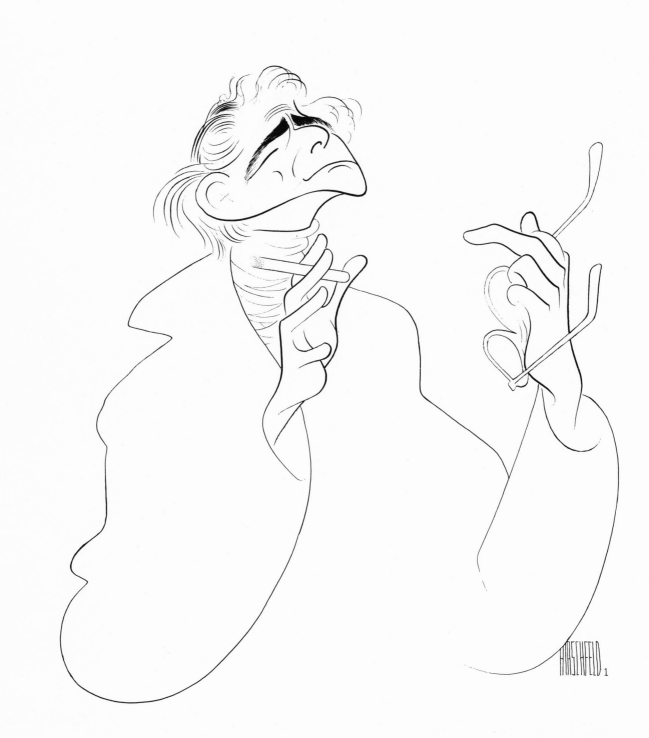

Leonard Bernstein

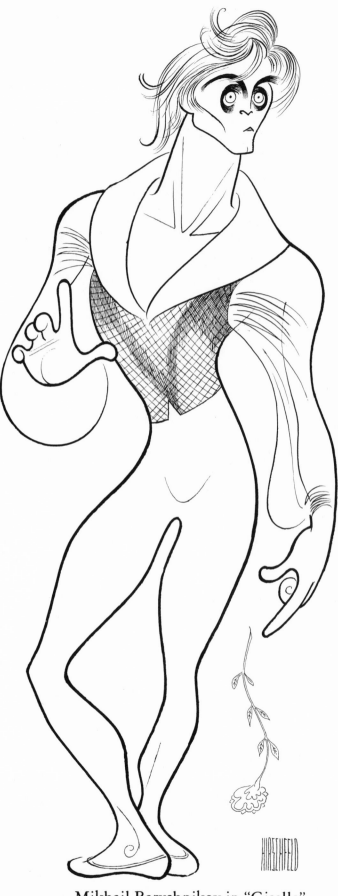

Mikhail Baryshnikov in "Giselle"

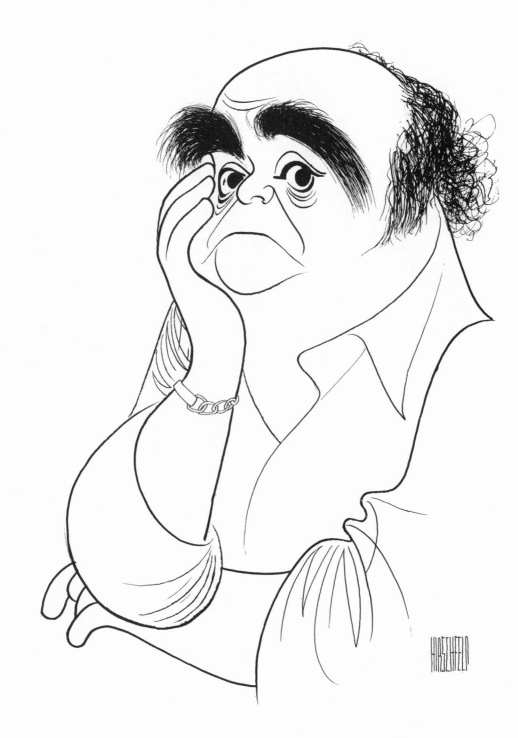

James Coco in "The Transfiguration of Benno Blimpie"

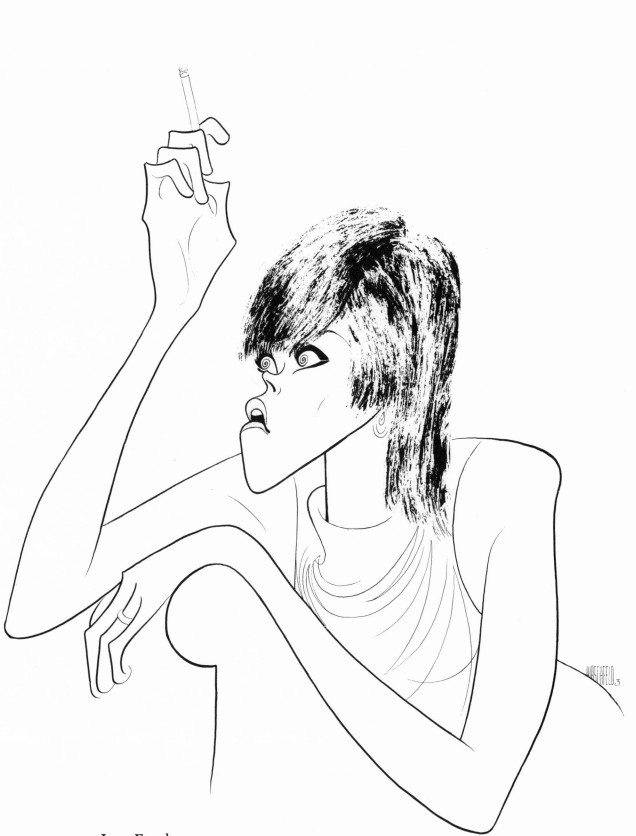

Jane Fonda

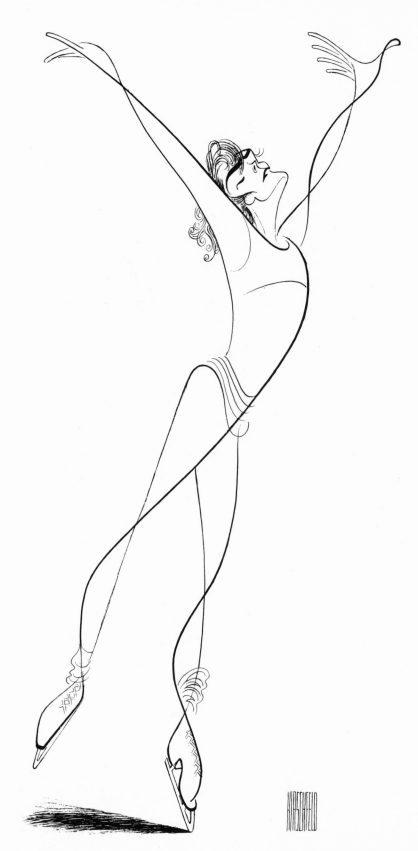

John Curry in "Ice Dancing"

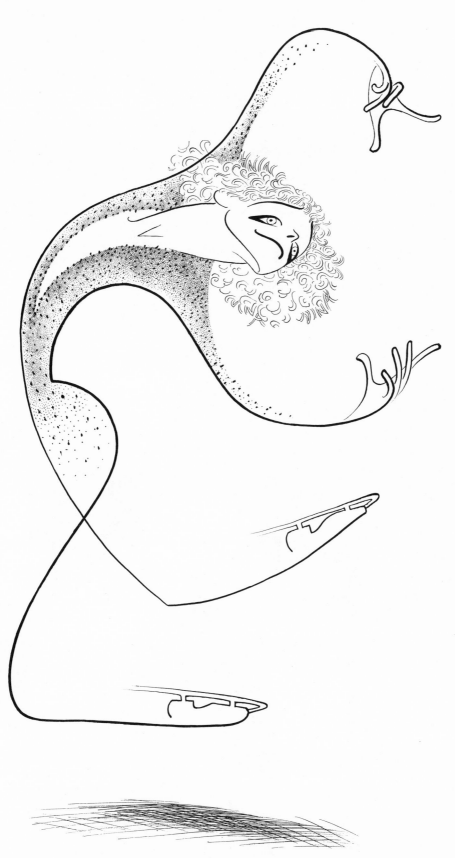

Toller Cranston in "The Ice Show"

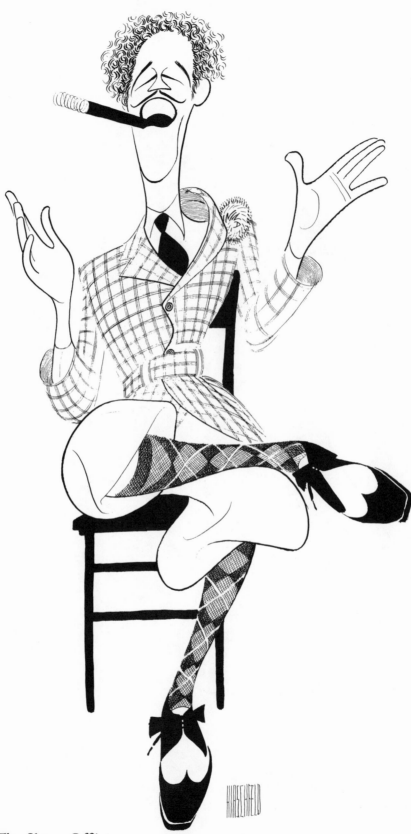

Paul Rudd in "The Show-Off"

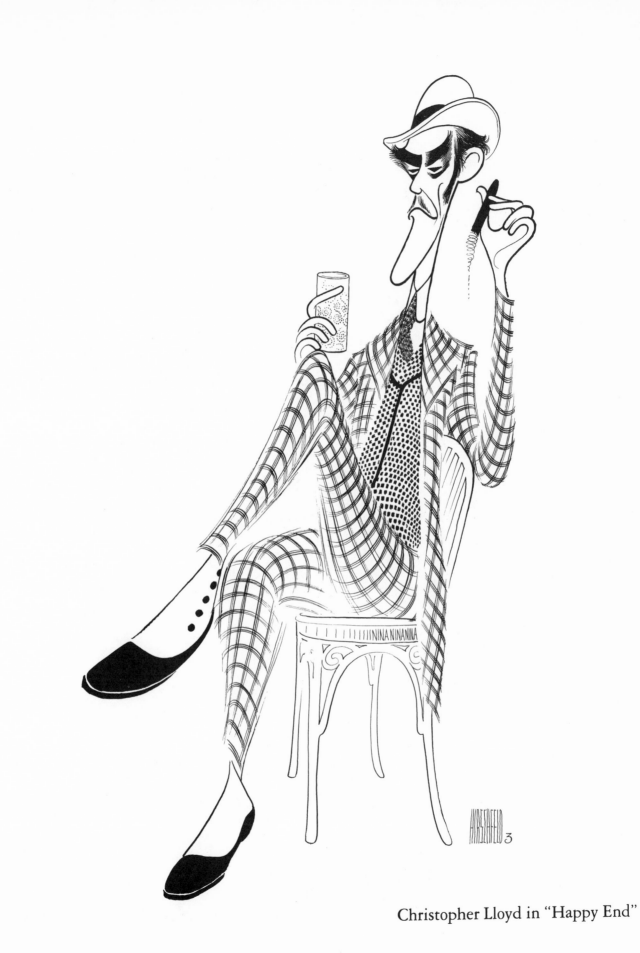

Christopher Lloyd in "Happy End"

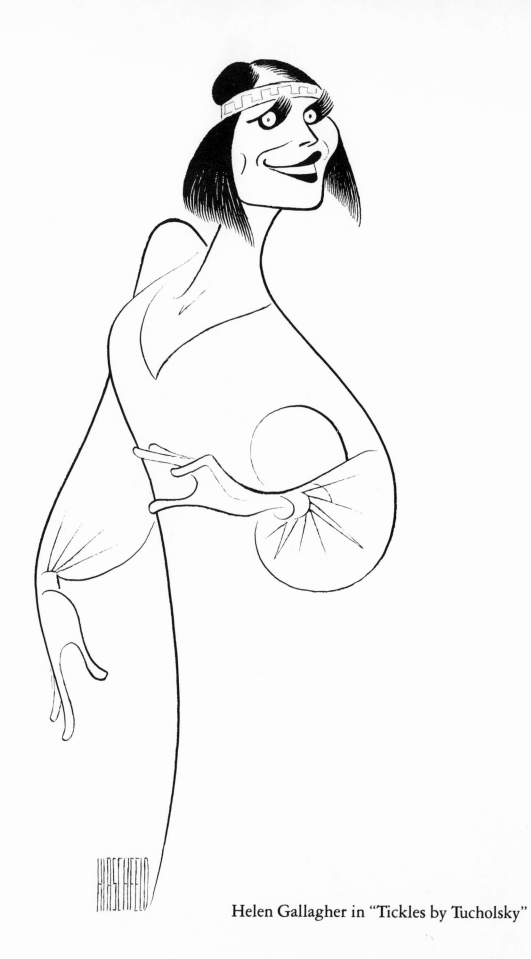

Helen Gallagher in "Tickles by Tucholsky"

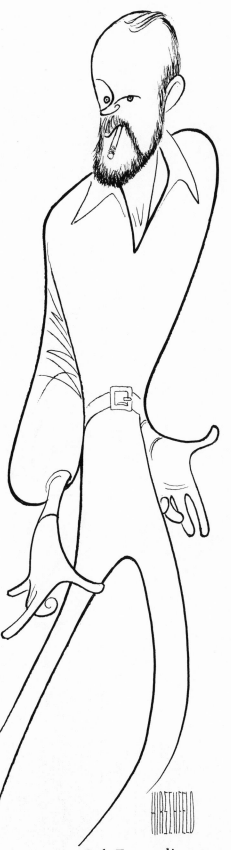

Bob Fosse, director and choreographer of "Dancin'"

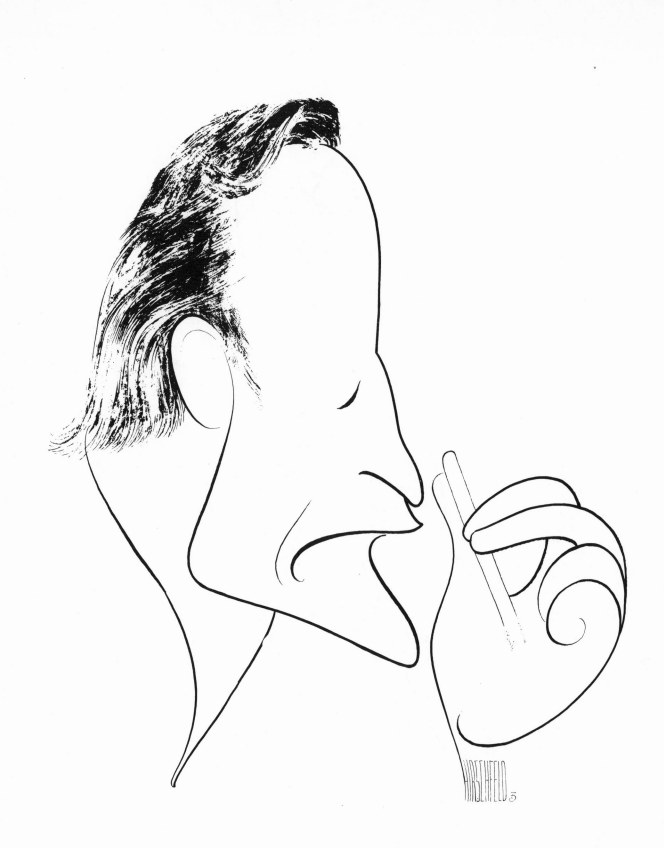

George C. Scott

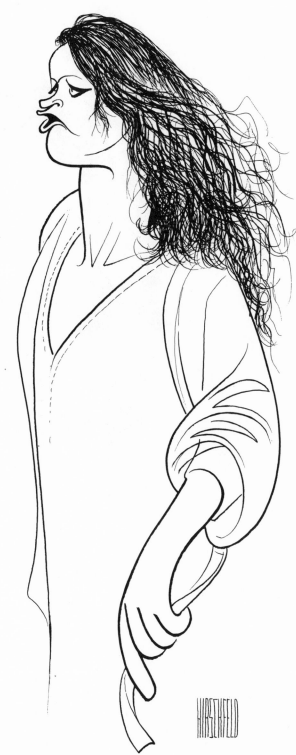

Colleen Dewhurst in "An Almost Perfect Person"

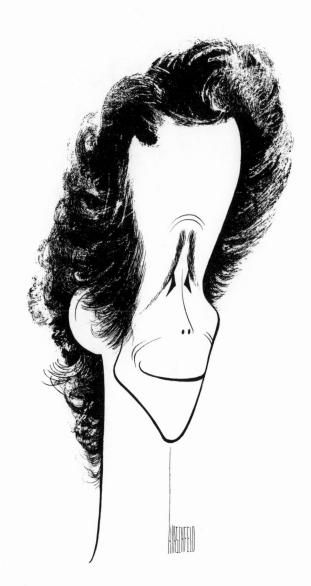

Joel Grey in "Marco Polo Sings a Solo"

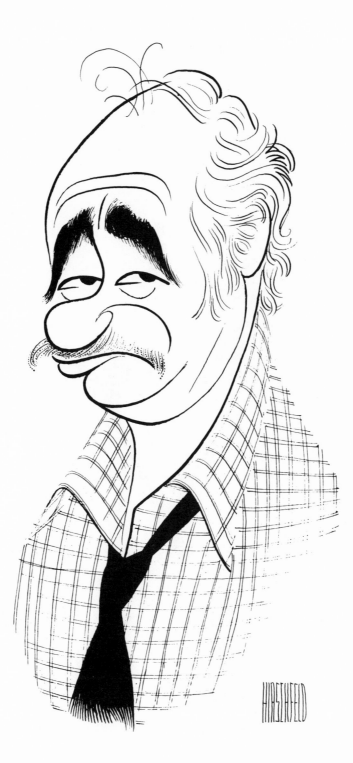

Martin Balsam in "Cold Storage"

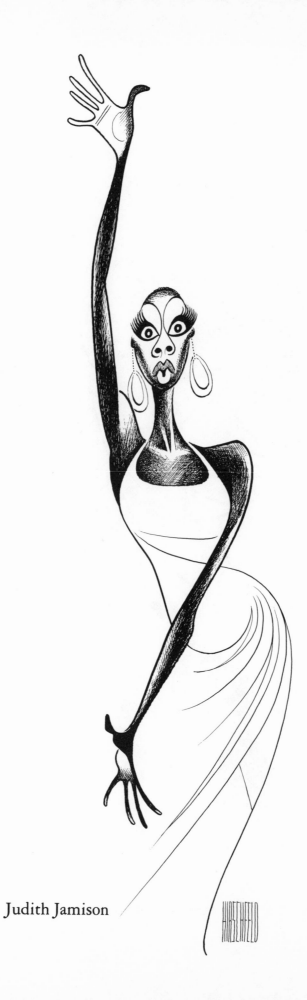

Judith Jamison

HIRSCHFELD

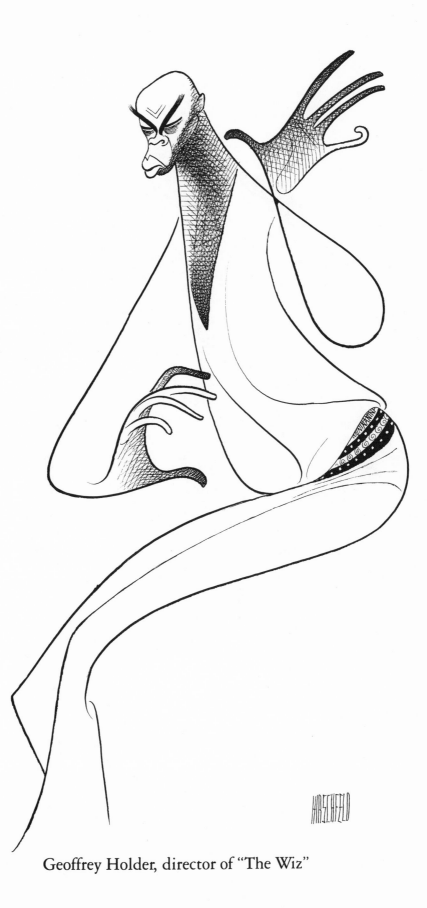

Geoffrey Holder, director of "The Wiz"

Sean O'Casey

Leo Lerman

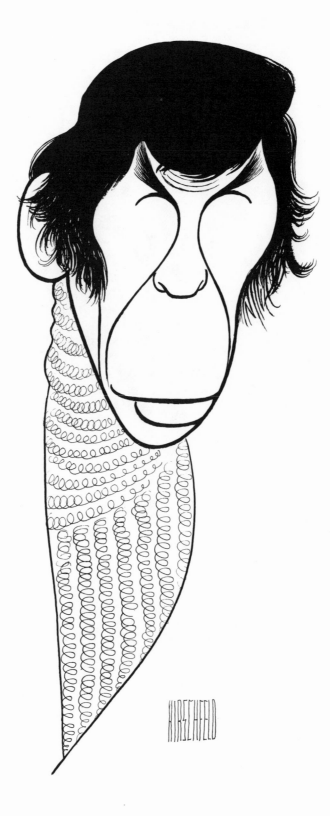

Leonard Nimoy in "Equus"

Robert Preston in "Sly Fox"

Julie Harris in "The Belle of Amherst"

Julie N. McKenzie in "Side by Side by Sondheim"

Lily Tomlin in "Appearing Nitely"

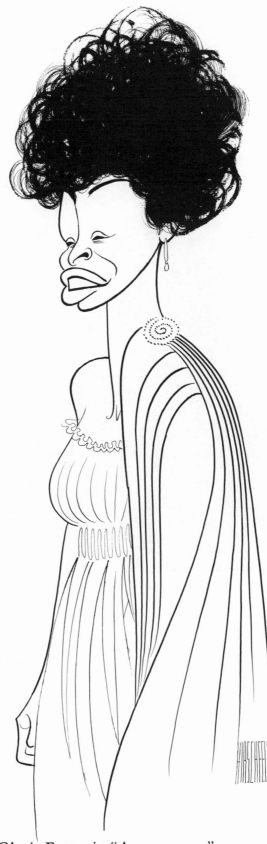

Gloria Foster in "Agamemnon"

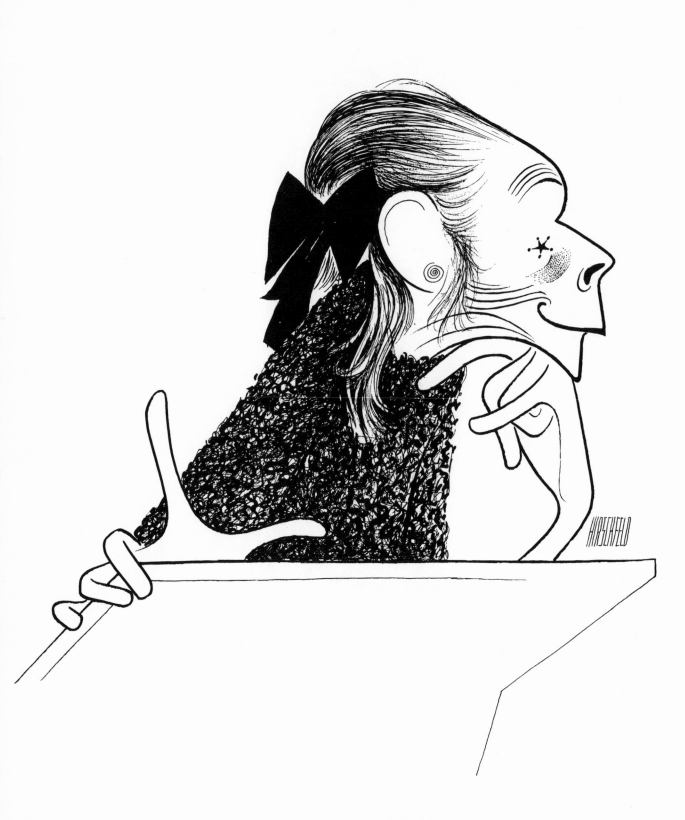

Ruth Gordon

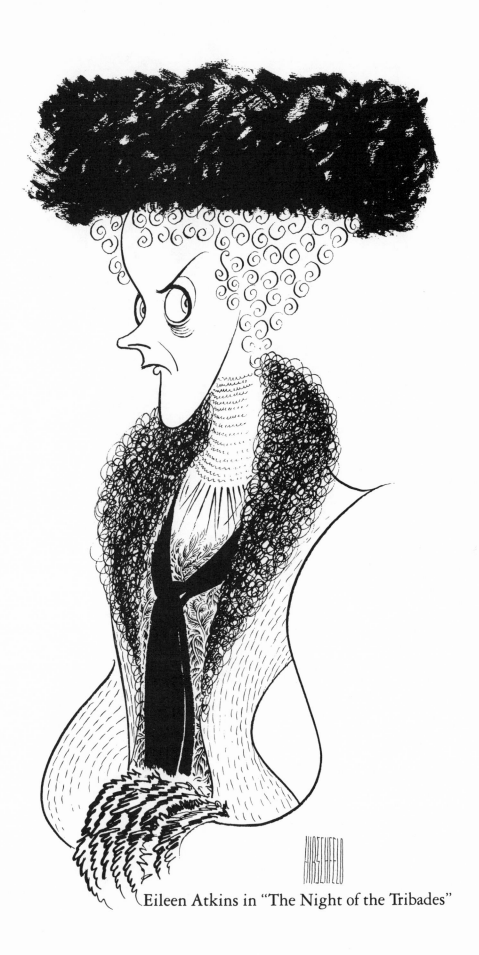

Eileen Atkins in "The Night of the Tribades"

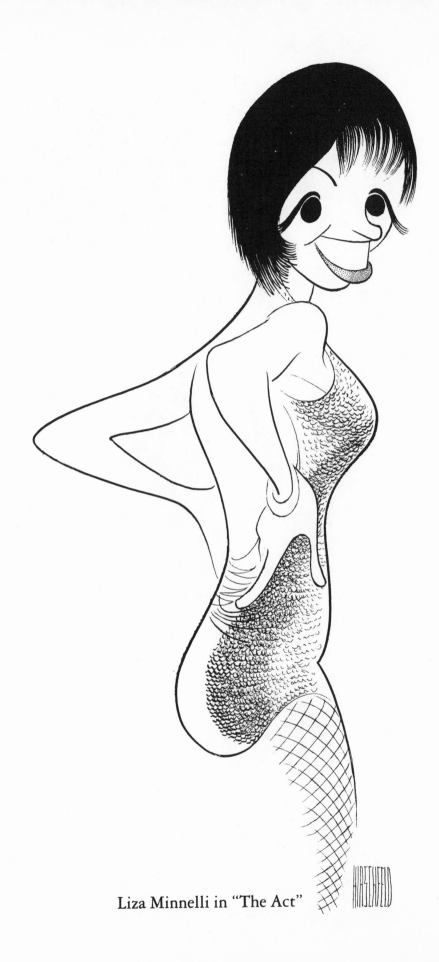

Liza Minnelli in "The Act"

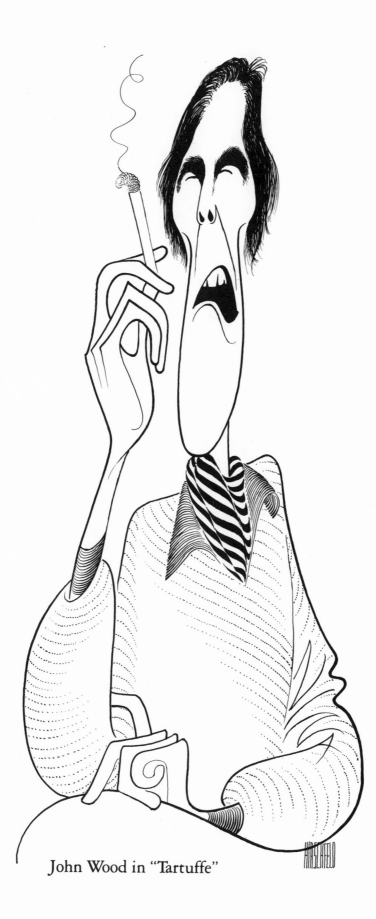

John Wood in "Tartuffe"

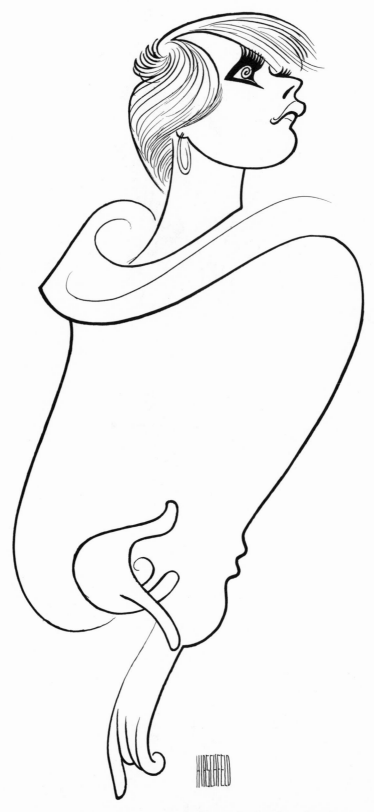

Nancy Dussault in "Side by Side by Sondheim"

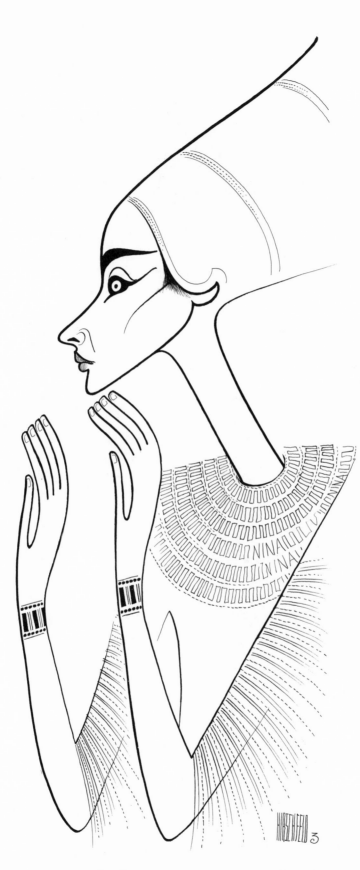

Andrea Marcovicci in "Nefertiti"

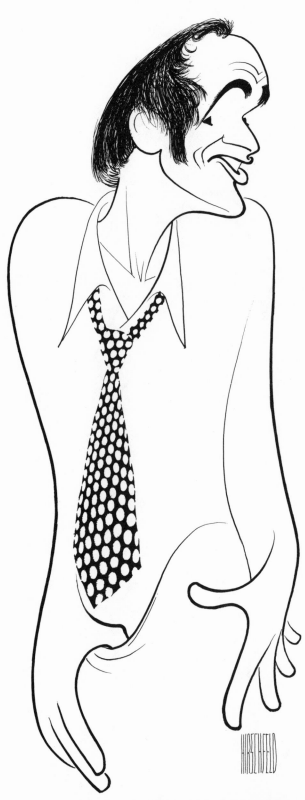

Larry Kert in "Side by Side by Sondheim"

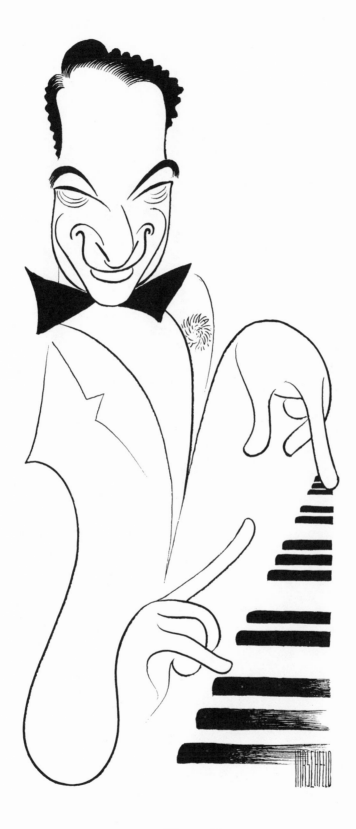

Victor Borge

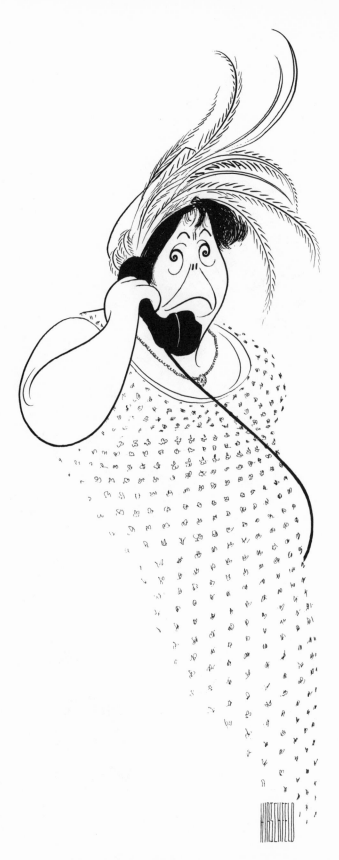

Helen Burns in "Catsplay"

Rose Gregorio in "The Shadow Box"

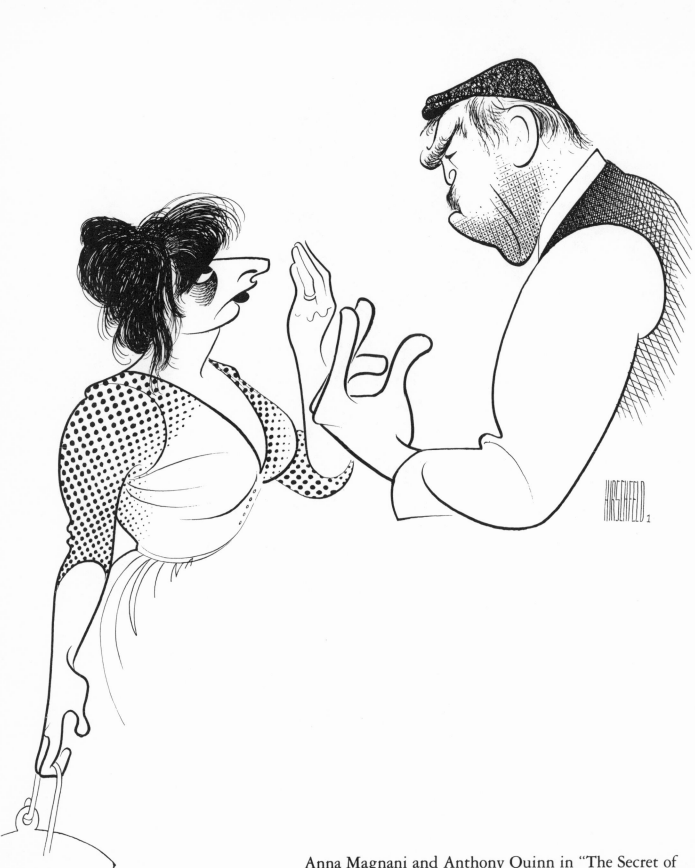

Anna Magnani and Anthony Quinn in "The Secret of Santa Vittoria"

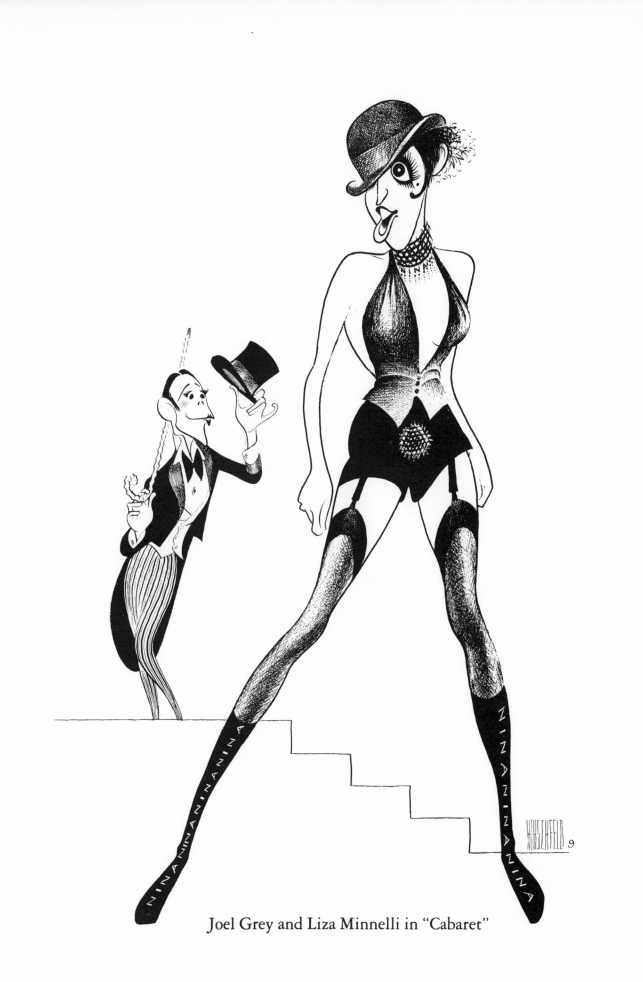

Joel Grey and Liza Minnelli in "Cabaret"

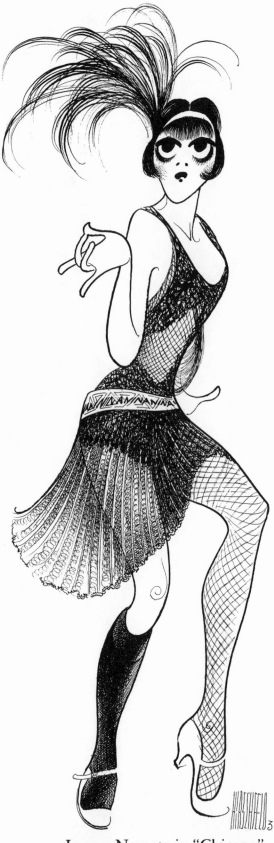

Lenora Nemetz in "Chicago"

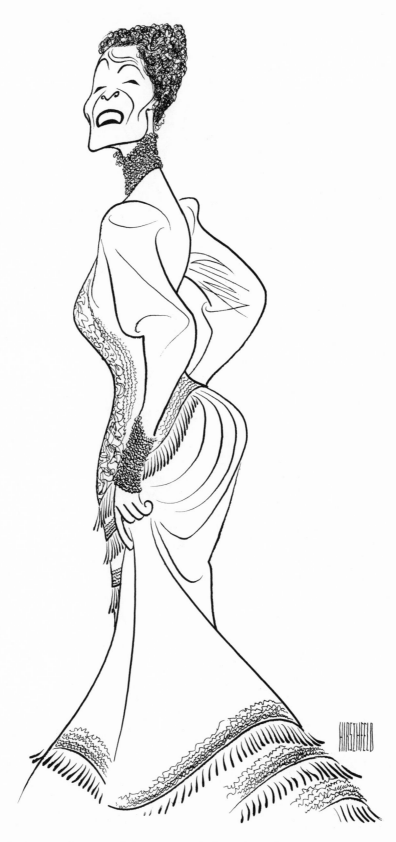

Gale Sondergaard in "John Gabriel Borkman"

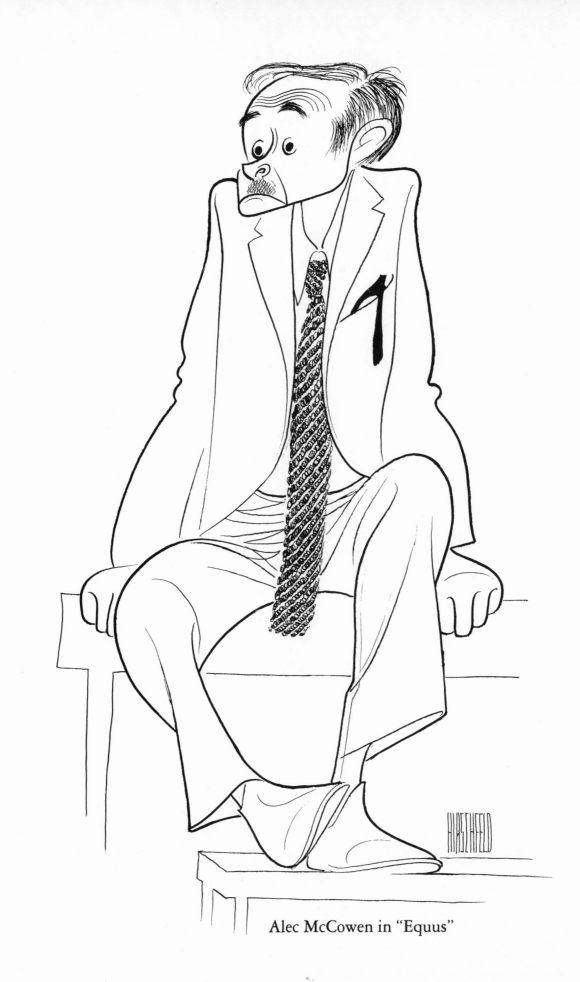

Alec McCowen in "Equus"

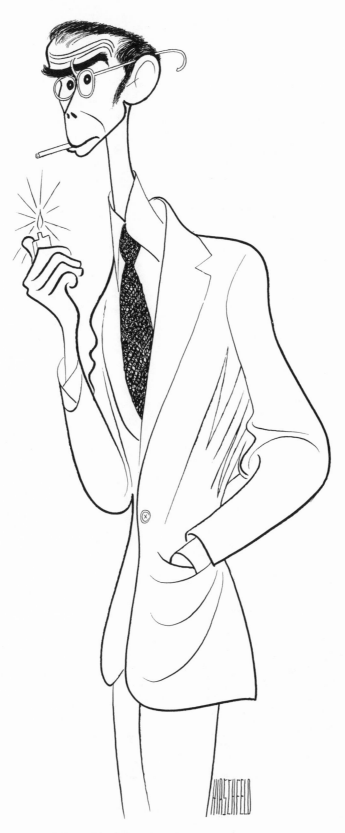

Tony Perkins in "Equus"

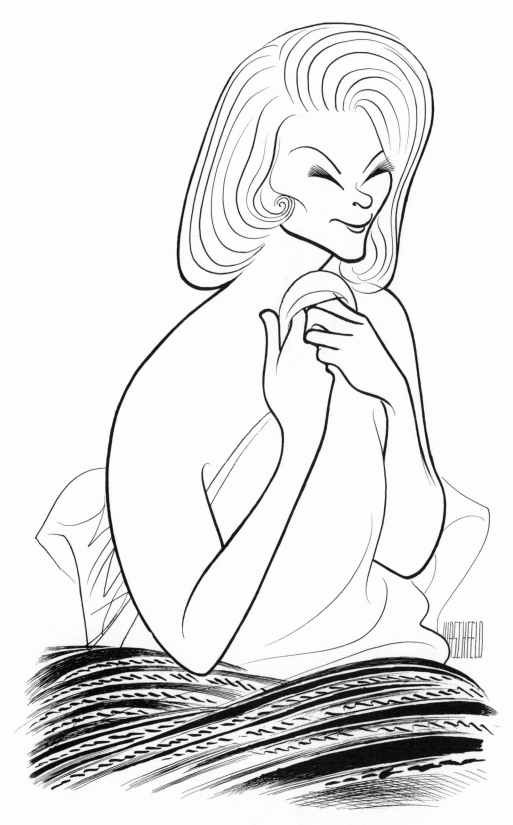

Hope Lange in "Same Time, Next Year"

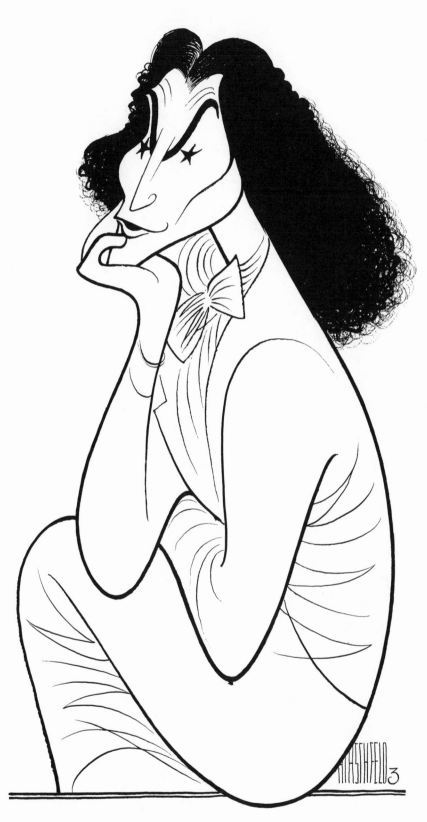

Marian Seldes in "Equus"

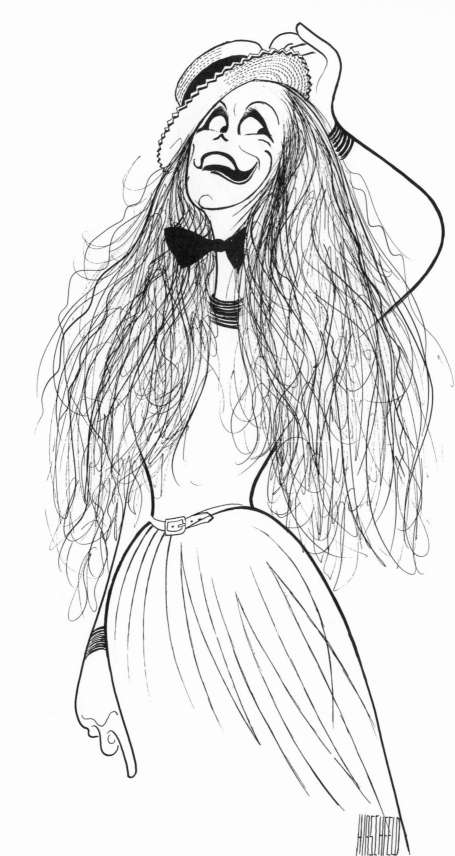

Geraldine Fitzgerald in "Street Songs"

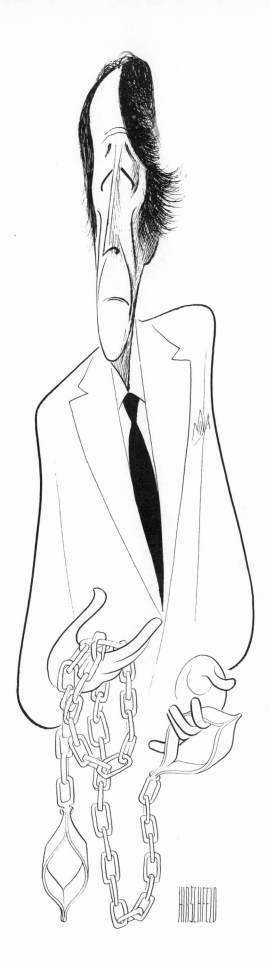

Fritz Weaver
in "The Biko Inquest"

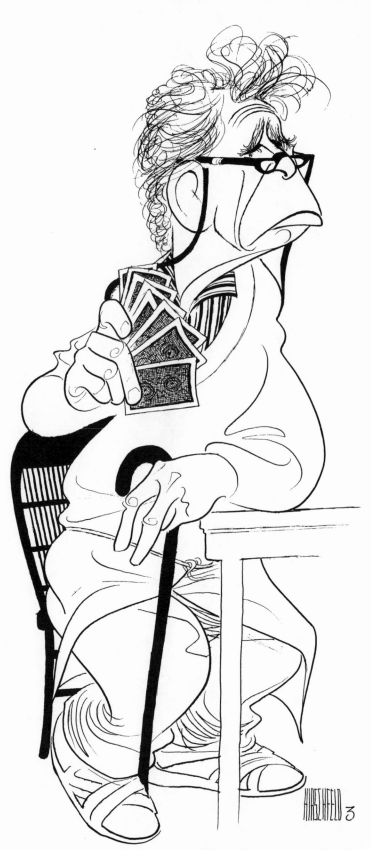

Hume Cronyn in "The Gin Game"

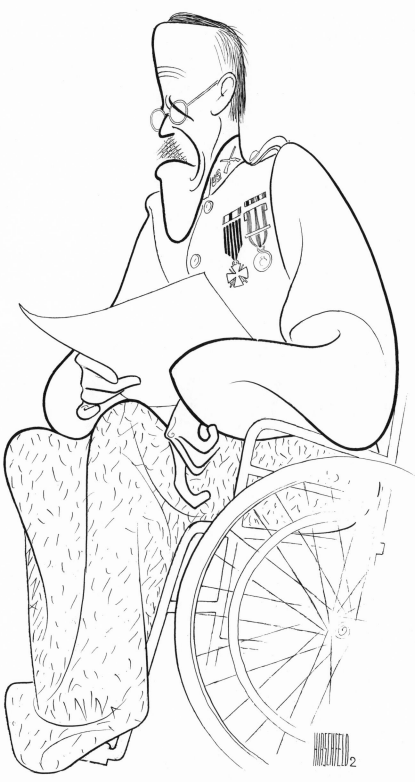

Fred Gwynne in "A Texas Trilogy"

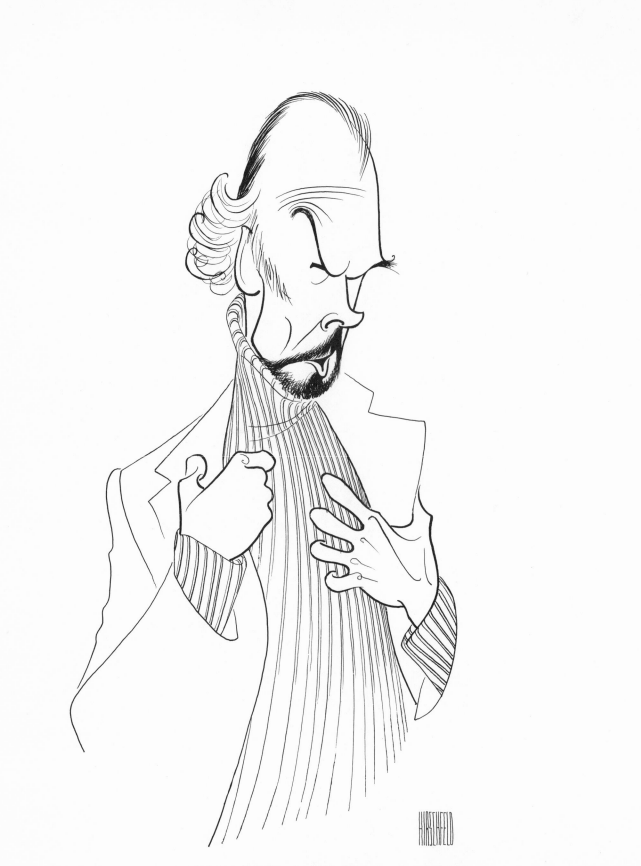

Richard Kiley in "Knickerbocker Holiday"

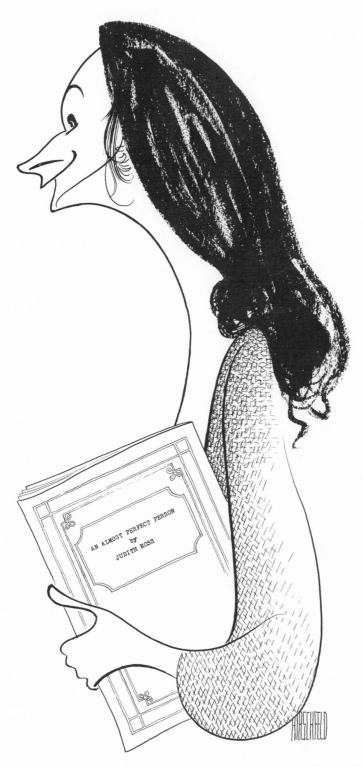

Zoe Caldwell directs "An Almost Perfect Person"

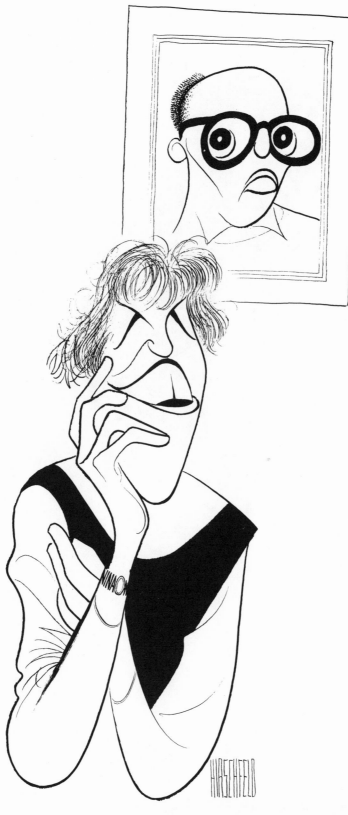

Kurt Weill and Lotte Lenya

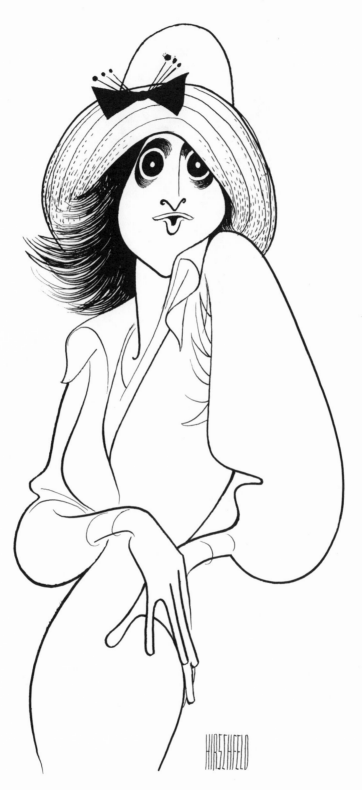

Patti Perkins
in "Tuscaloosa's Calling Me . . . but I'm Not Going!"

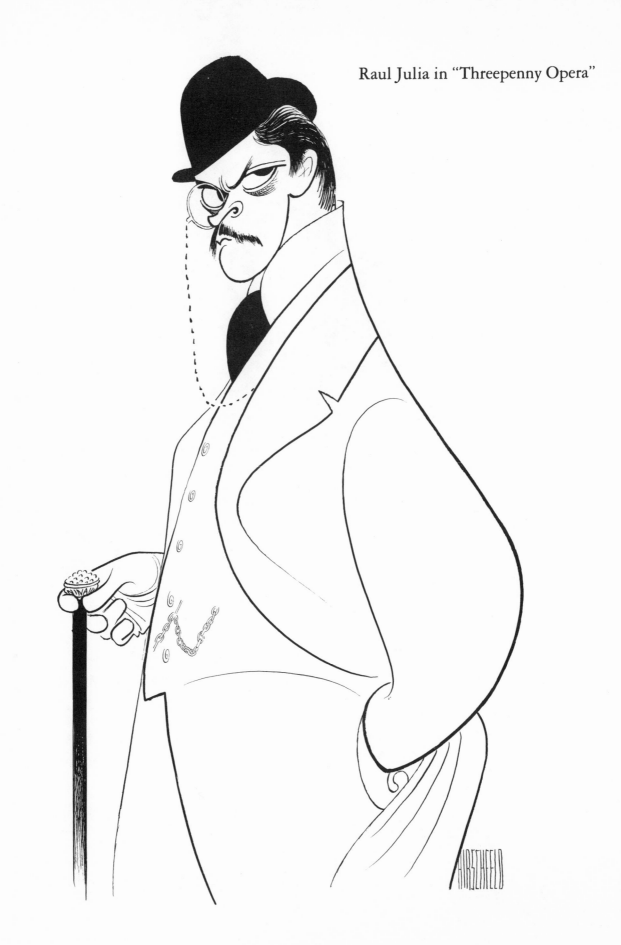

Raul Julia in "Threepenny Opera"

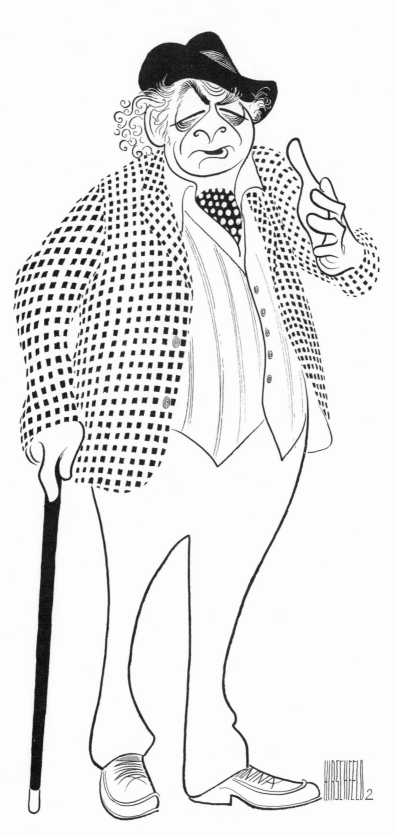

Allen Swift in "Checking Out"

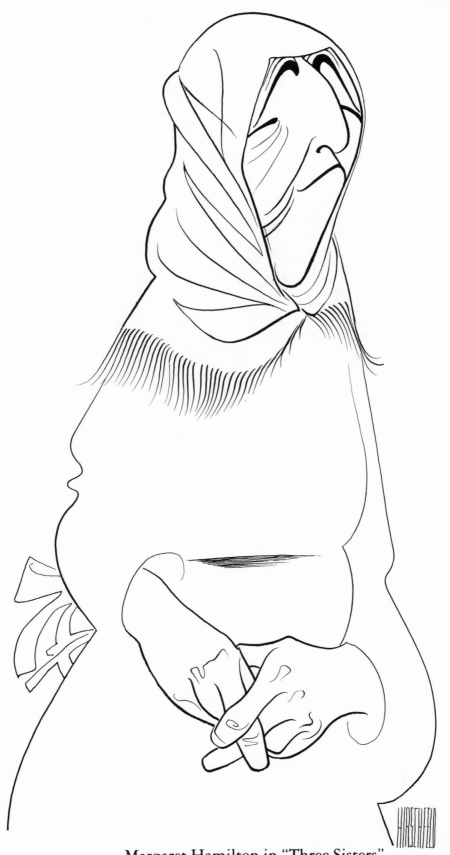

Margaret Hamilton in "Three Sisters"

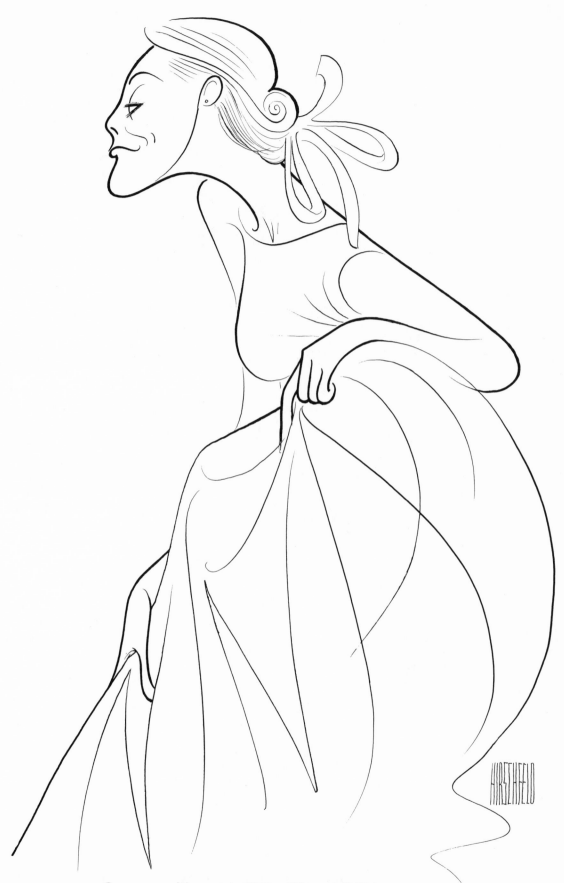

Constance Towers in "The King and I"

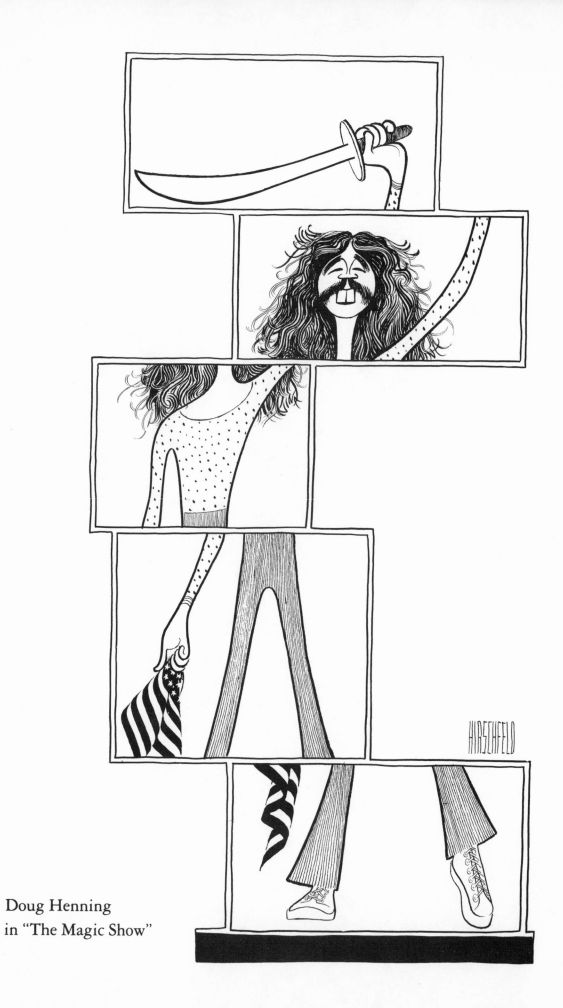

Doug Henning
in "The Magic Show"

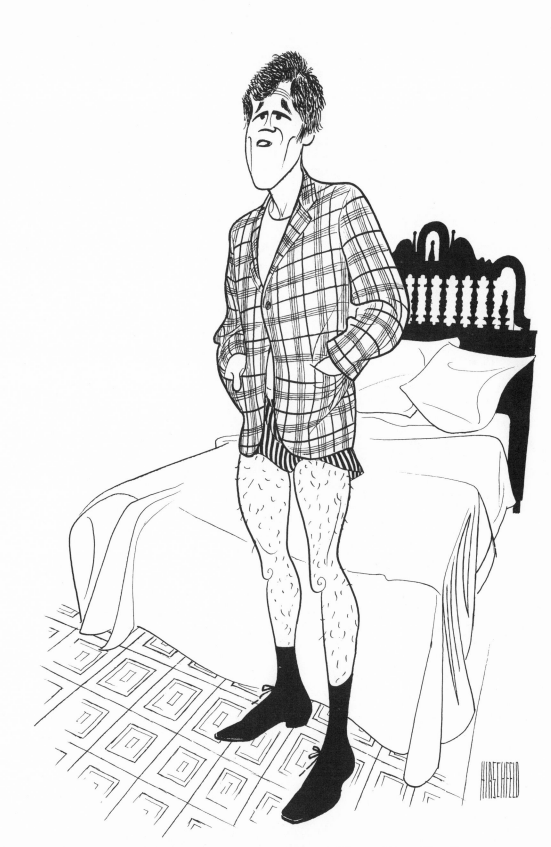

Don Murray in "Same Time, Next Year"

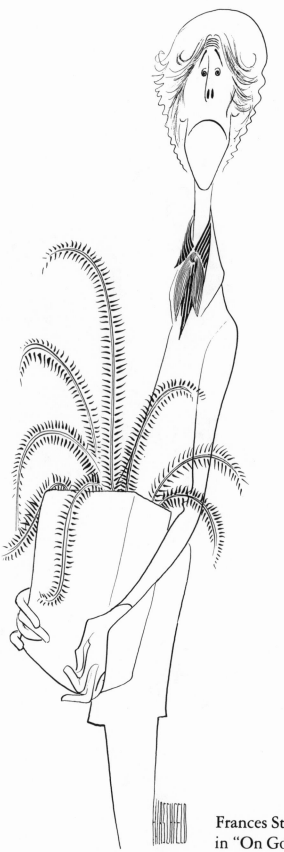

Frances Sternhagen
in "On Golden Pond"

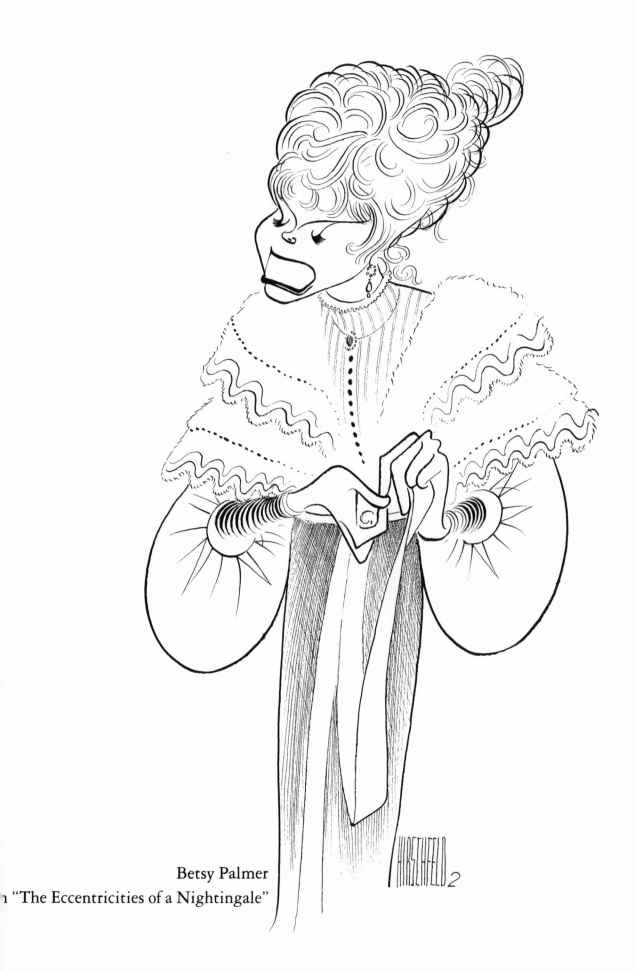

Betsy Palmer
in "The Eccentricities of a Nightingale"

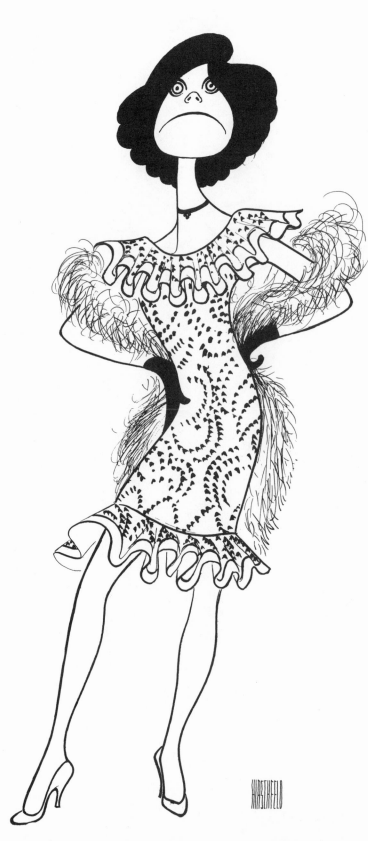

Swoosie Kurtz in "A History of the American Film"

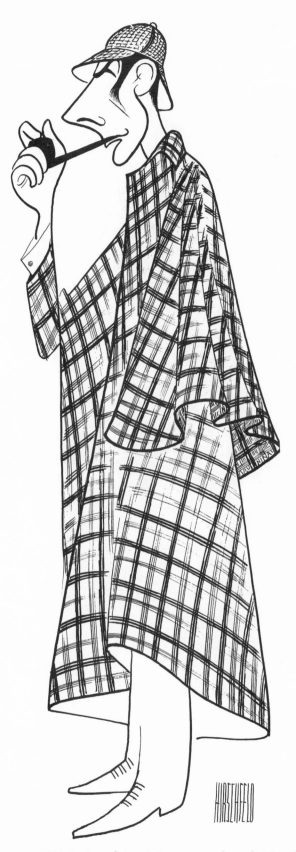

Paxton Whitehead in "The Crucifer of Blood"

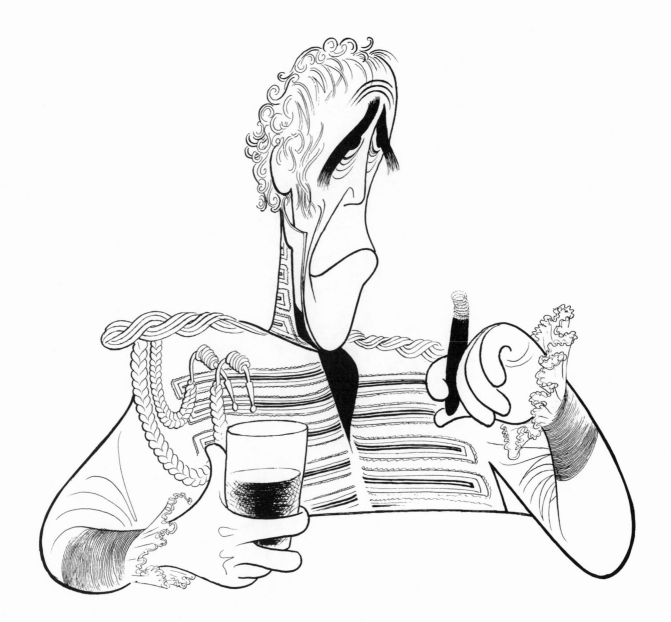

Jason Robards, Jr. in "A Touch of the Poet"

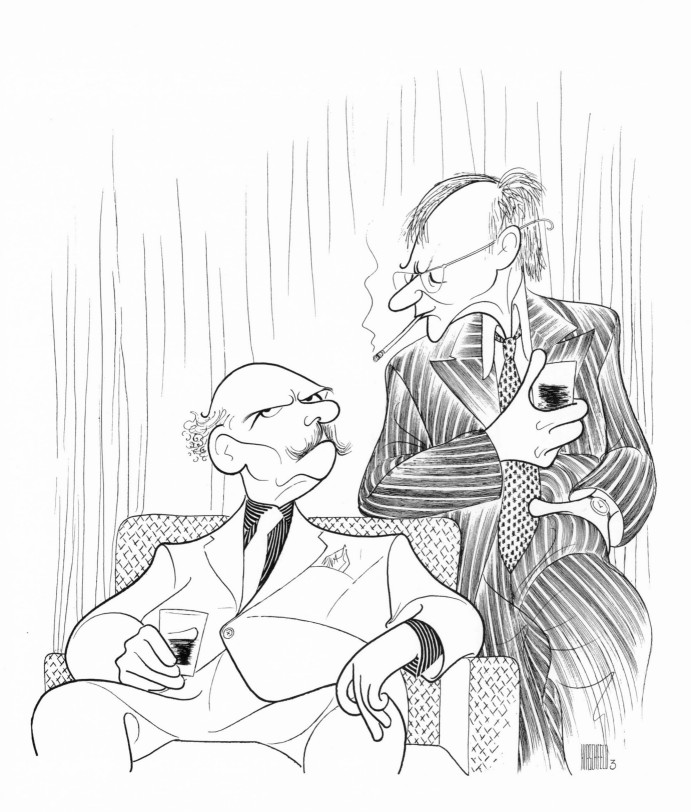

Ralph Richardson and John Gielgud in "No Man's Land"

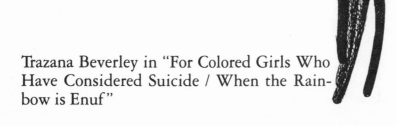

Trazana Beverley in "For Colored Girls Who
Have Considered Suicide / When the Rain-
bow is Enuf"

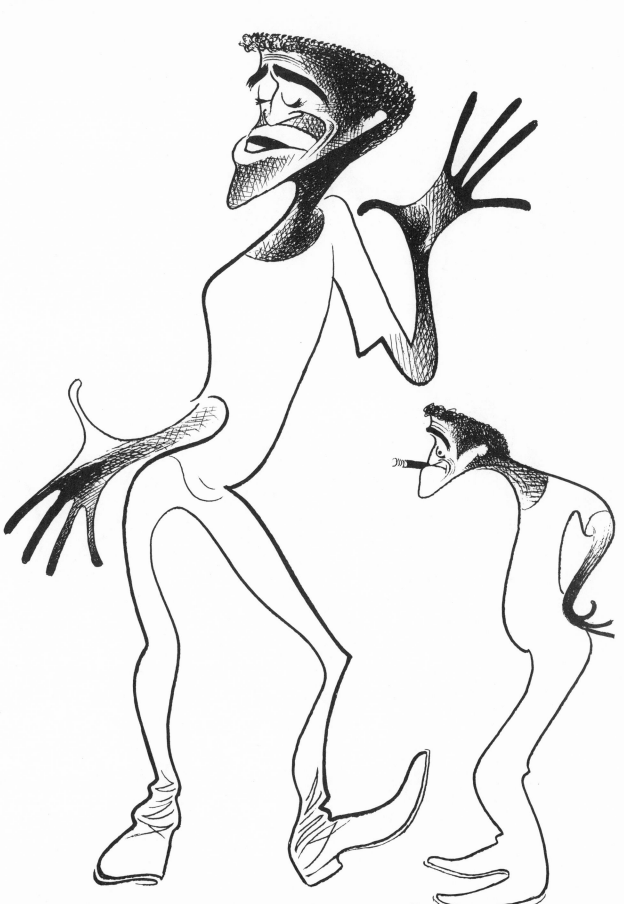

Sammy Davis, Jr. in "Stop the World — I Want to Get Off"

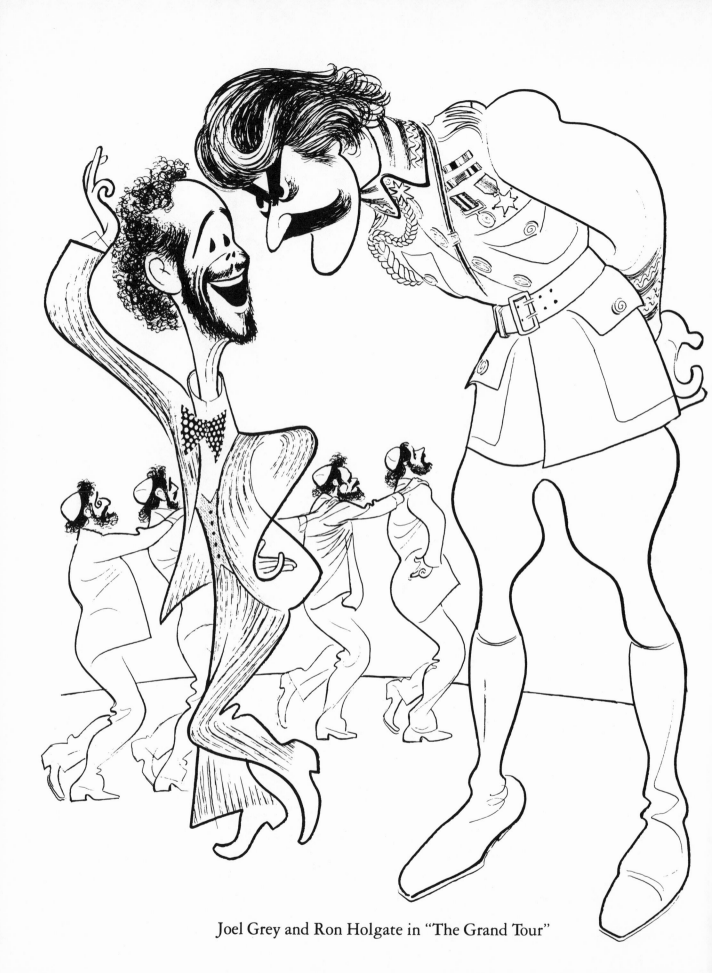

Joel Grey and Ron Holgate in "The Grand Tour"

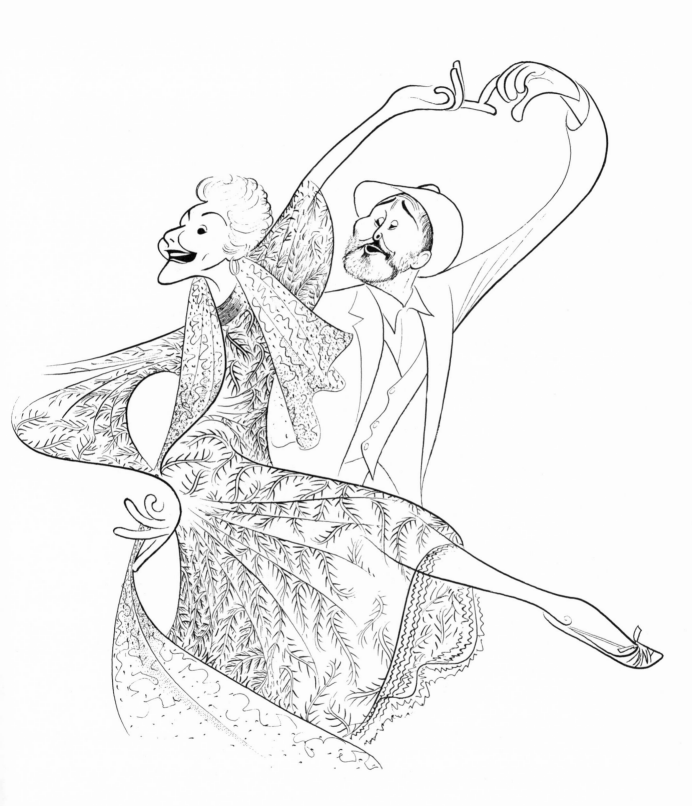

Mary Martin and Anthony Quayle in "Do You Turn Somersaults?"

Maureen Stapleton and Pamela Payton-Wright in "The Glass Menagerie"

Jane Alexander and Richard Kiley in "The Heiress"

Barbara Baxley in "Best Friend," Claire Bloom in "The Innocents," and Maria Schell in "Poor Murderer"

Golda Meir, with Anne Bancroft of "Golda"

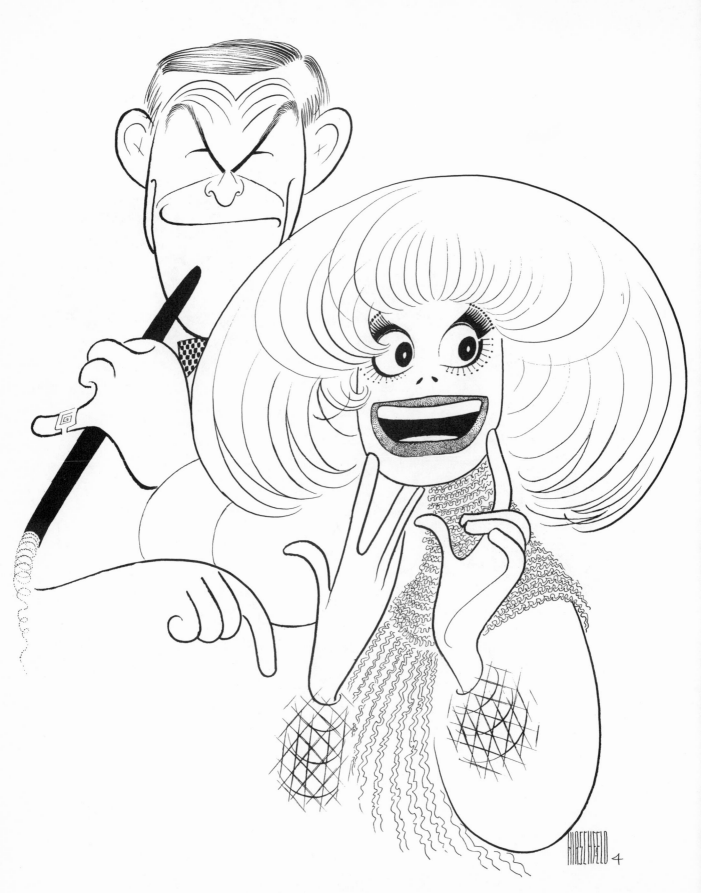

George Burns and Carol Channing

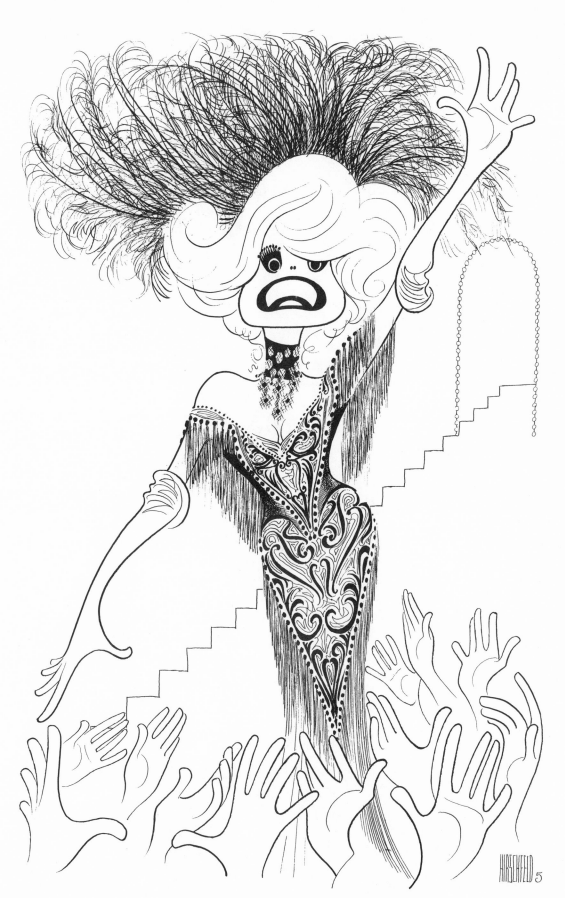

Carol Channing in "Hello, Dolly!"

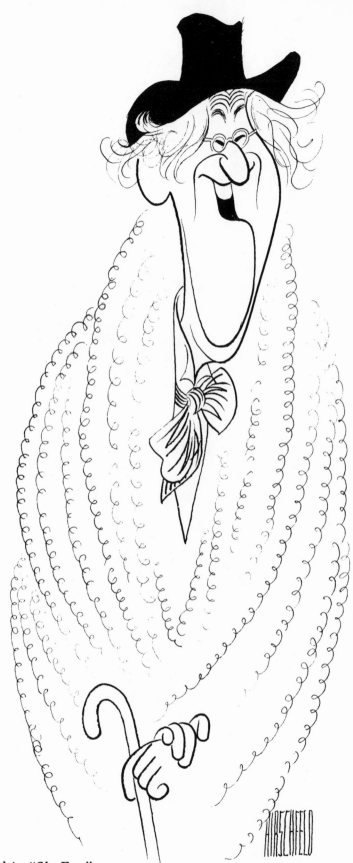

Jack Gilford in "Sly Fox"

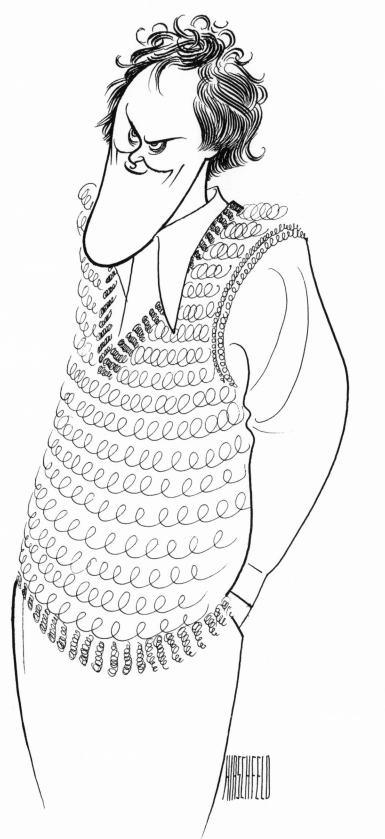

John Lithgow in "Anna Christie"

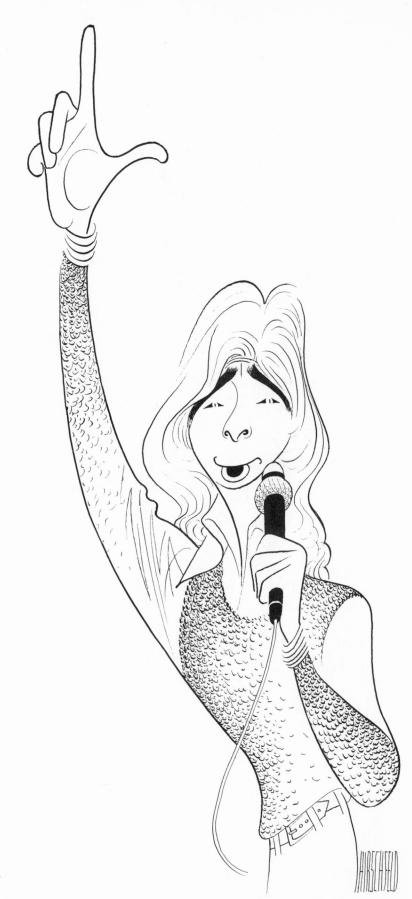

Barry Manilow

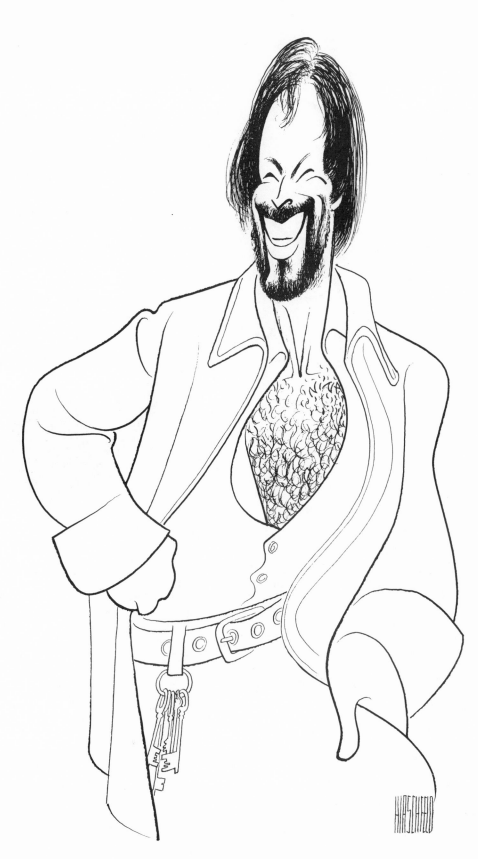

Richard Chamberlain in "The Night of the Iguana"

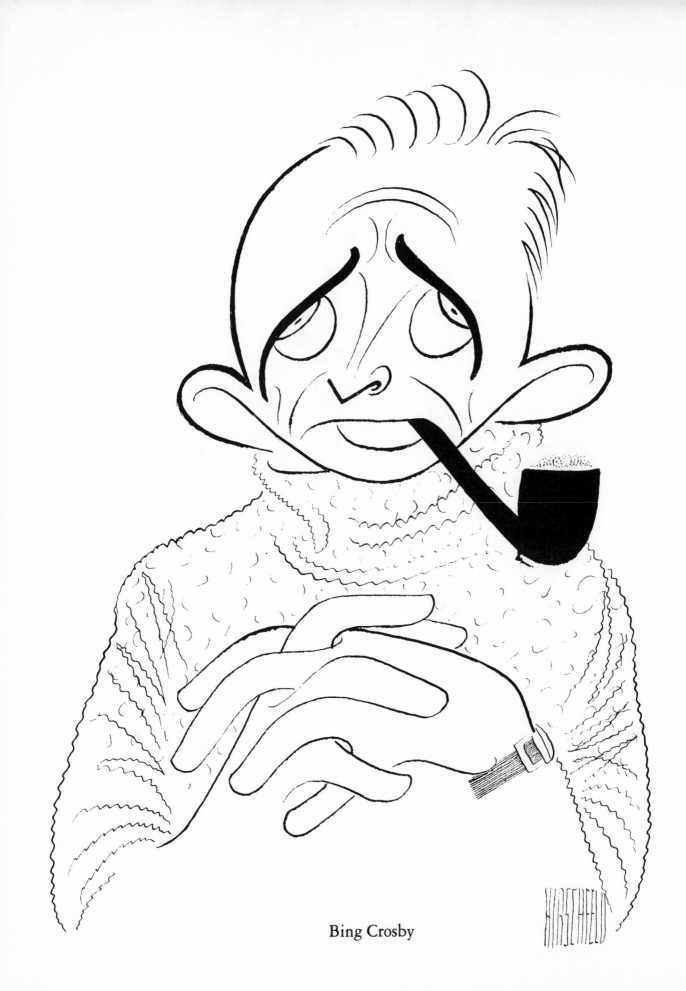

Bing Crosby

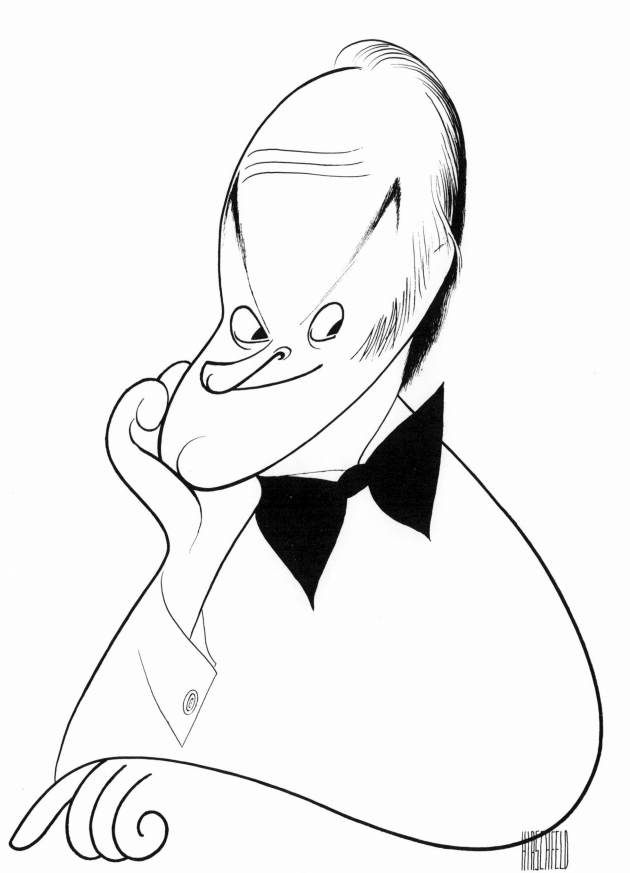

Bob Hope

Mary McCarty in "Anna Christie"

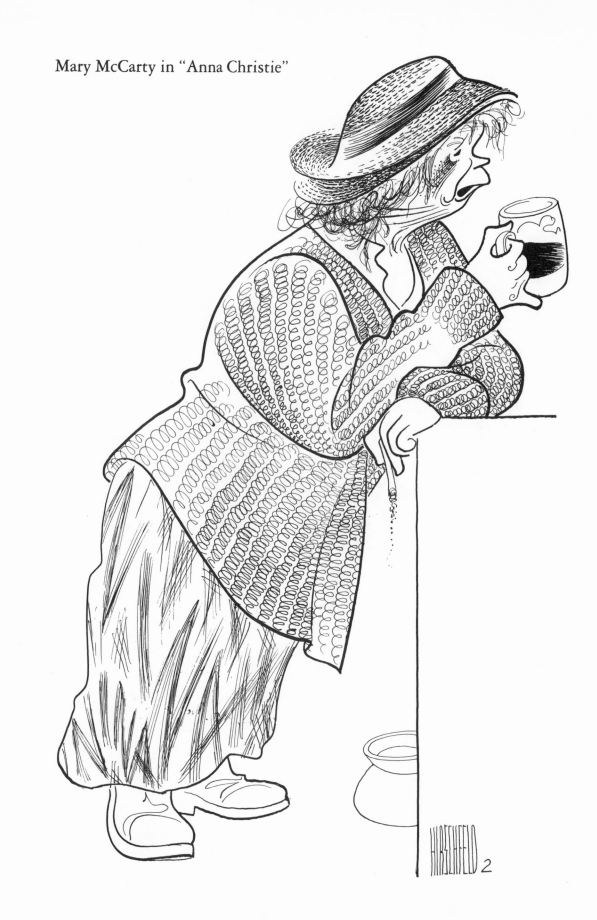

Zero Mostel in "Fiddler on the Roof"

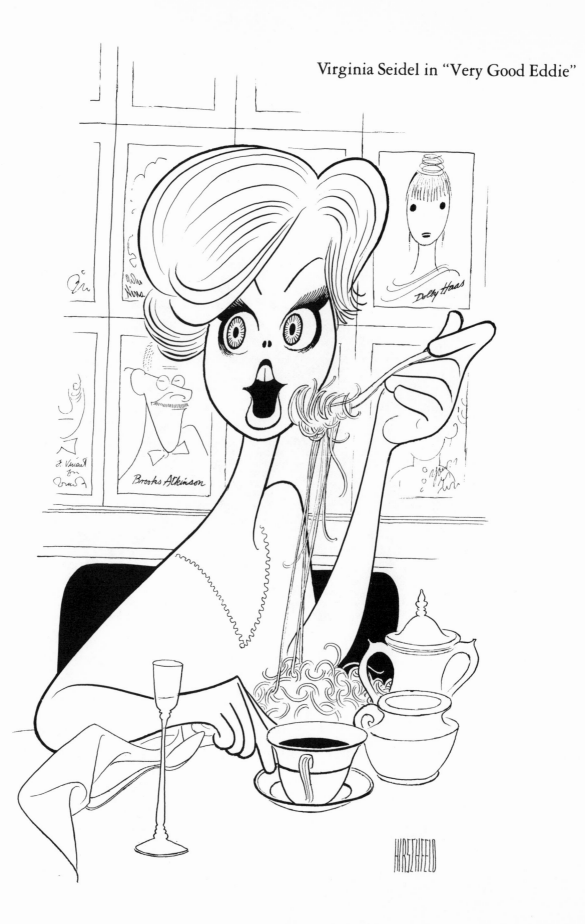

Virginia Seidel in "Very Good Eddie"

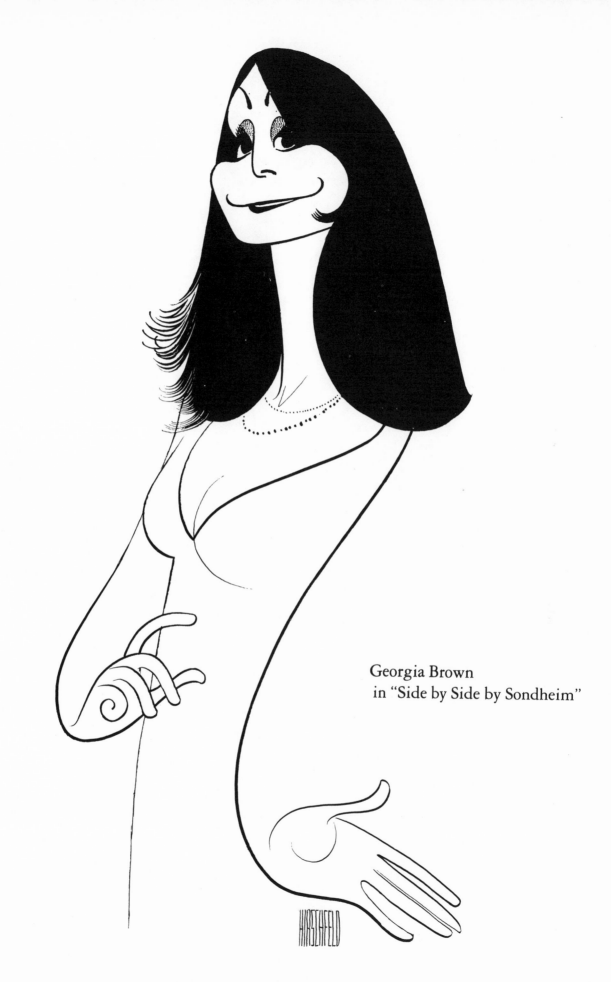

Georgia Brown
in "Side by Side by Sondheim"

121

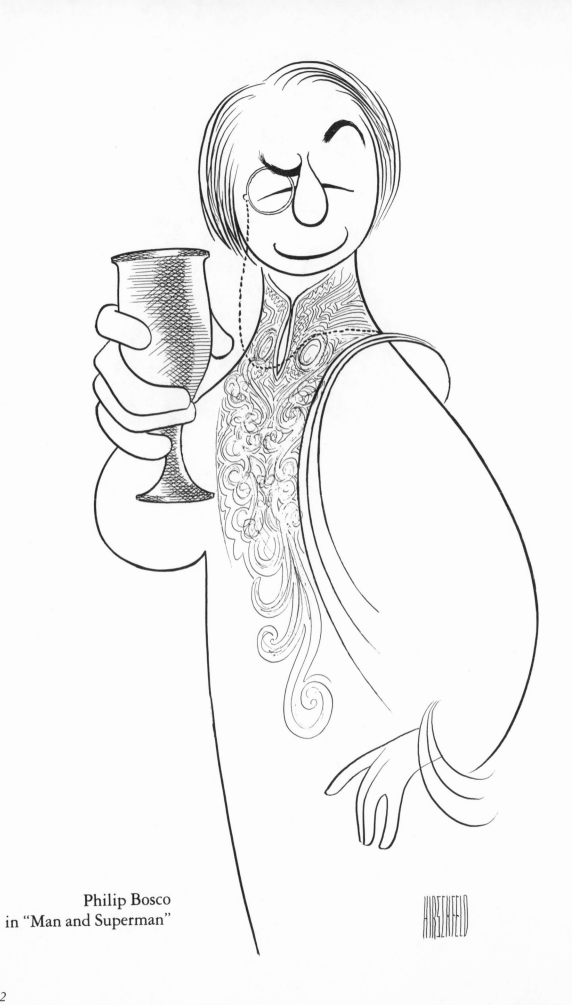

Philip Bosco
in "Man and Superman"

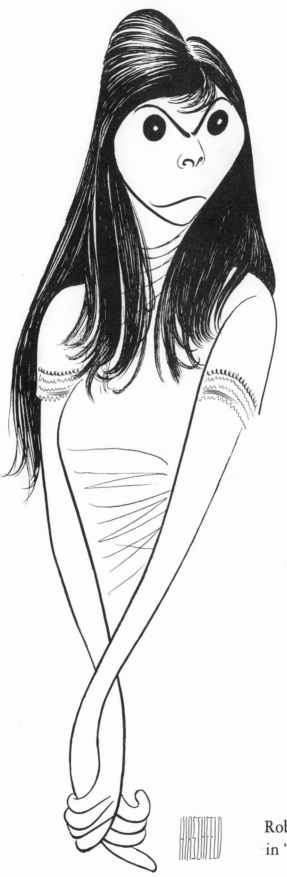

Roberta Wallach
in "The Diary of Anne Frank"

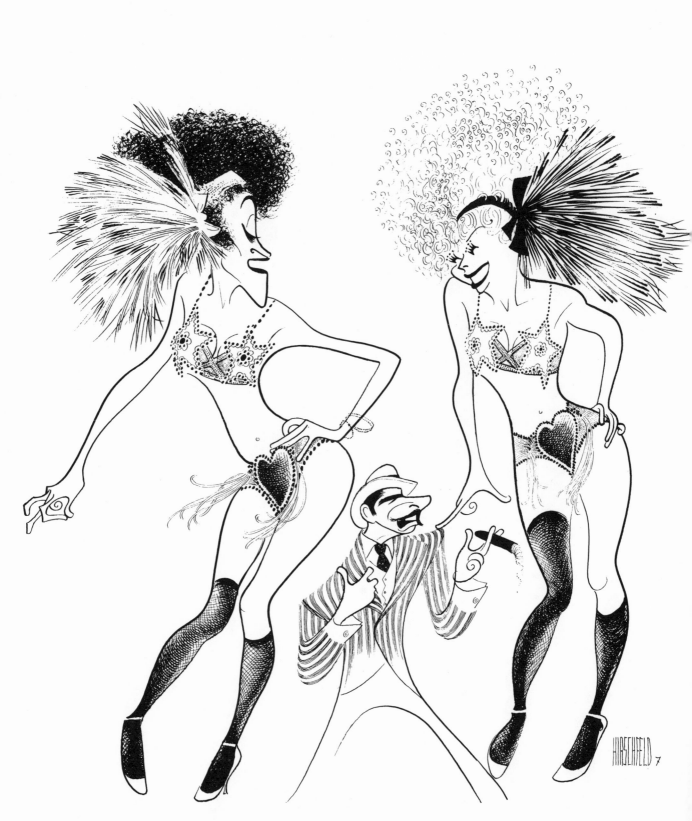

Chita Rivera, Jerry Orbach and Gwen Verdon in "Chicago"

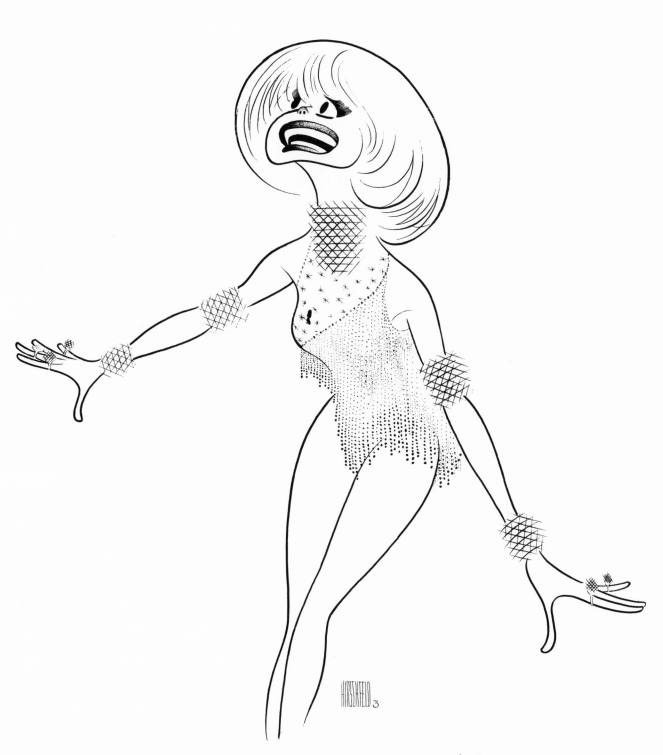

Carol Channing in "Gentlemen Prefer Blondes"

Alan Bates in "Butley"

Warren Beatty

Katharine Hepburn in "The Glass Menagerie"

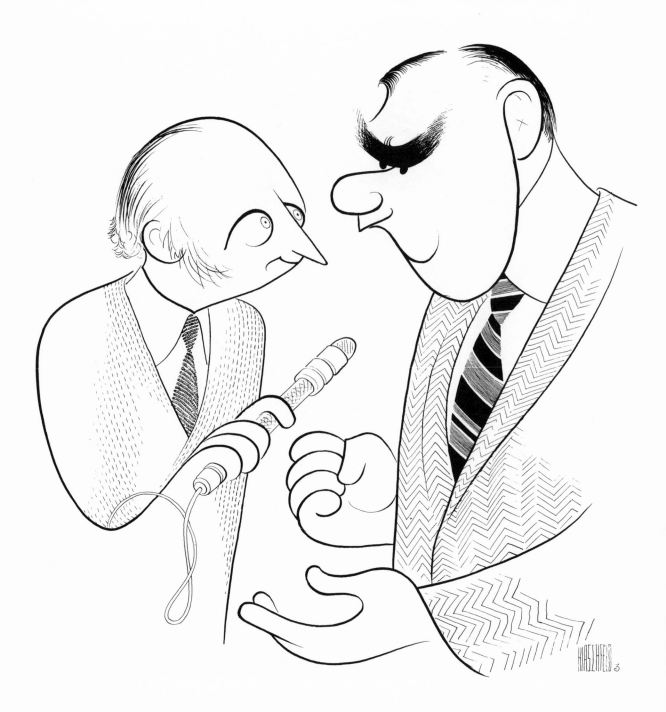

Bob Elliott and Ray Goulding in "Bob and Ray — The Two and Only"

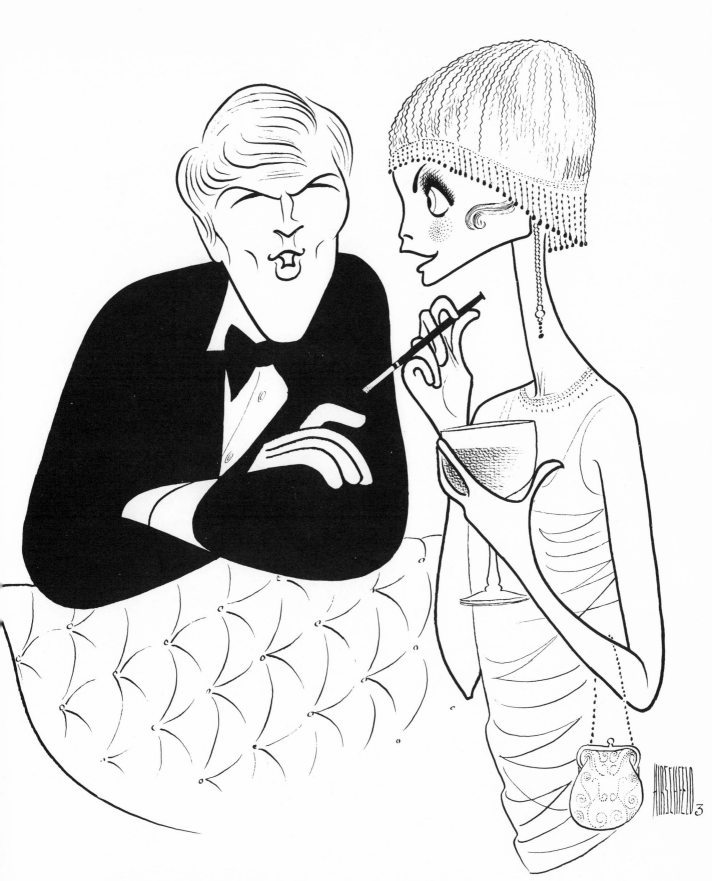

Robert Redford and Mia Farrow in "The Great Gatsby"

Shirley Knight

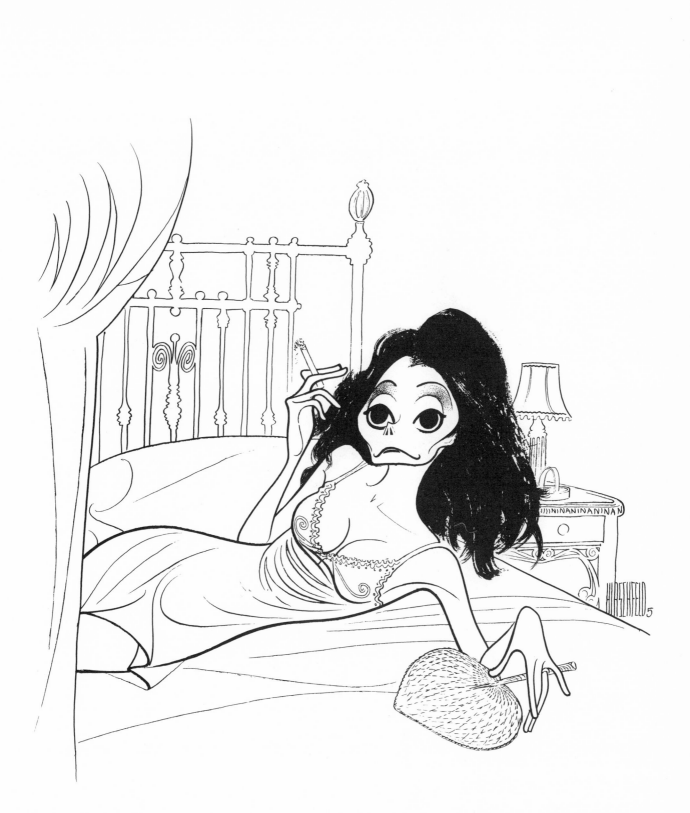

Elizabeth Ashley in "Cat on a Hot Tin Roof"

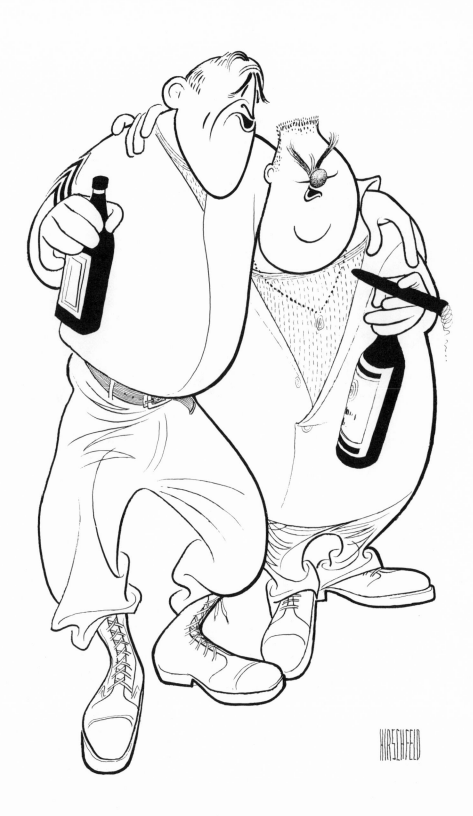

Kenneth McMillan and Dolph Sweet in "Streamers"

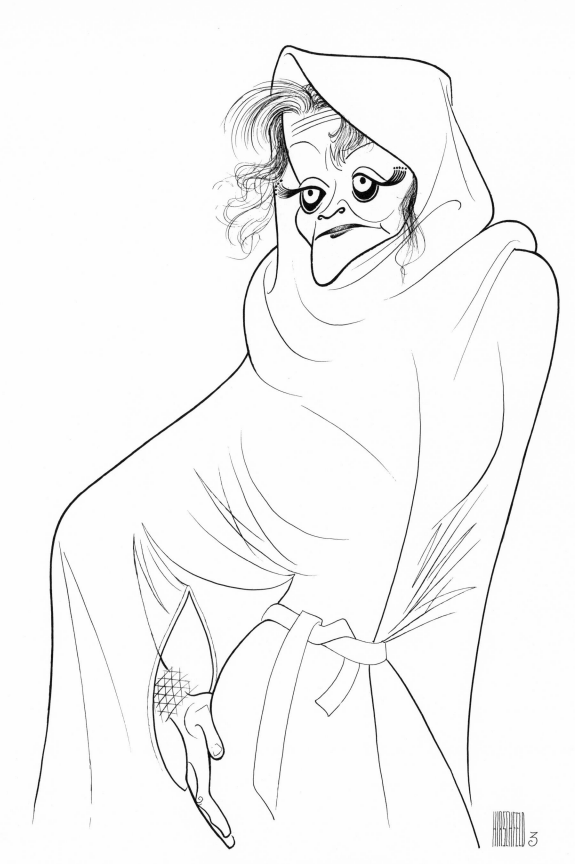

Sylvia Sidney in "Vieux Carré"

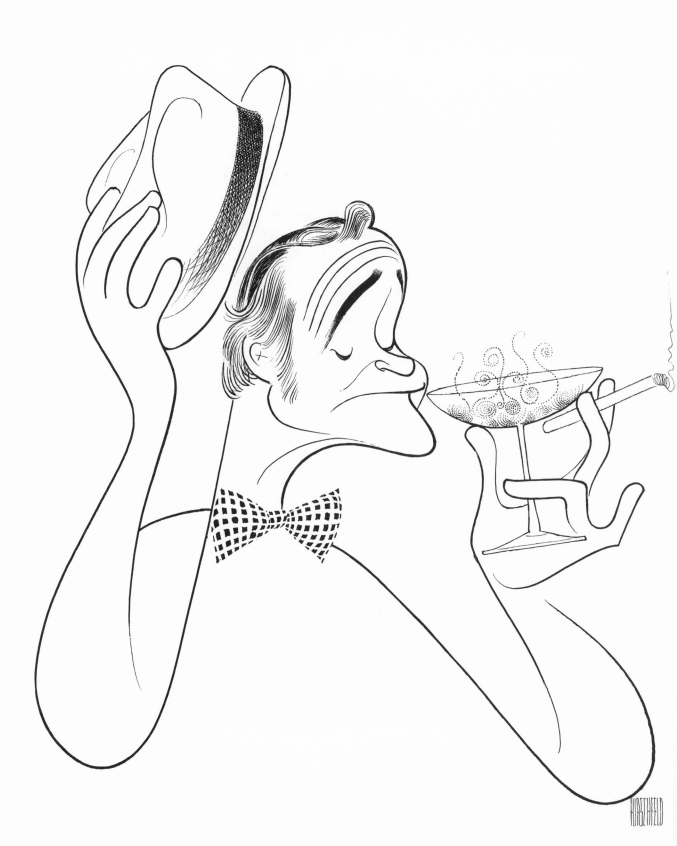

Jack Lemmon in "Tribute"

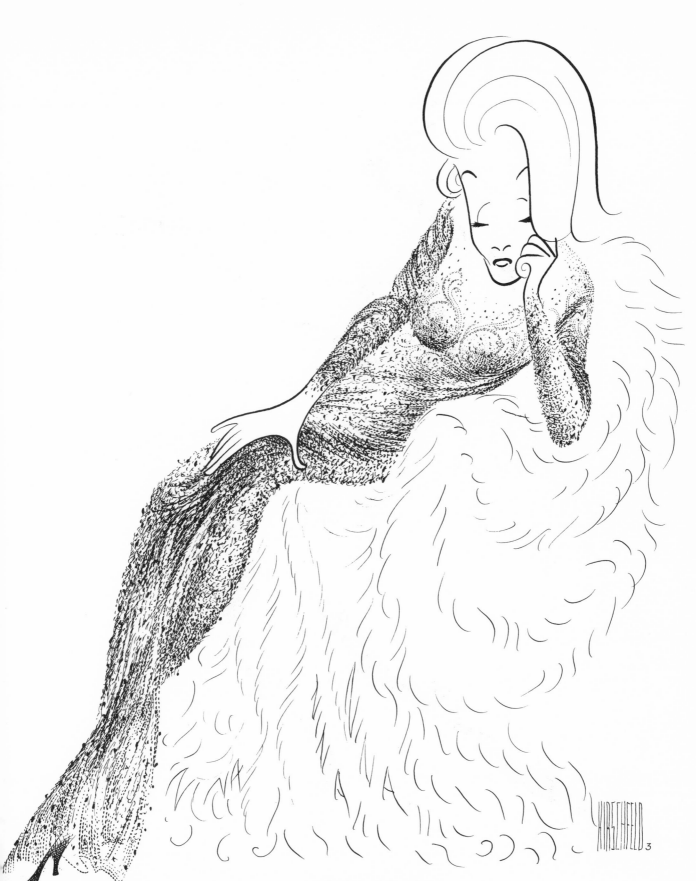

Marlene Dietrich

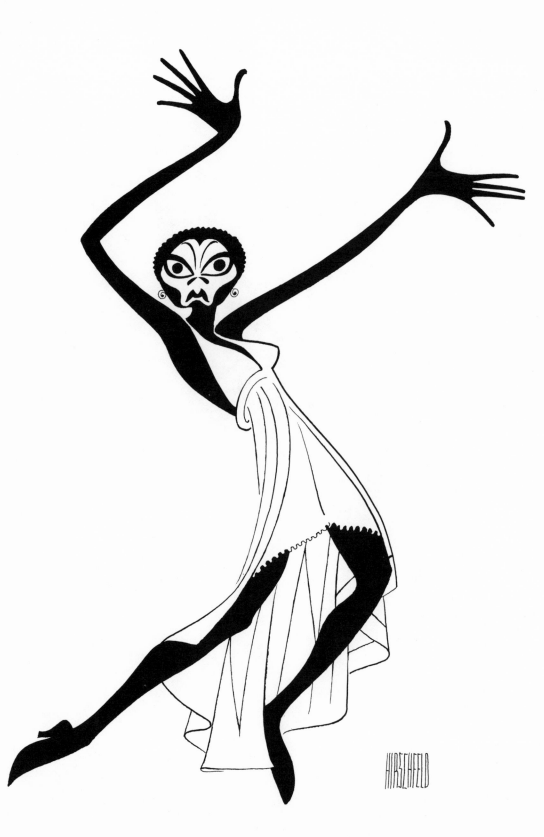

Vivian Reed in "Bubbling Brown Sugar"

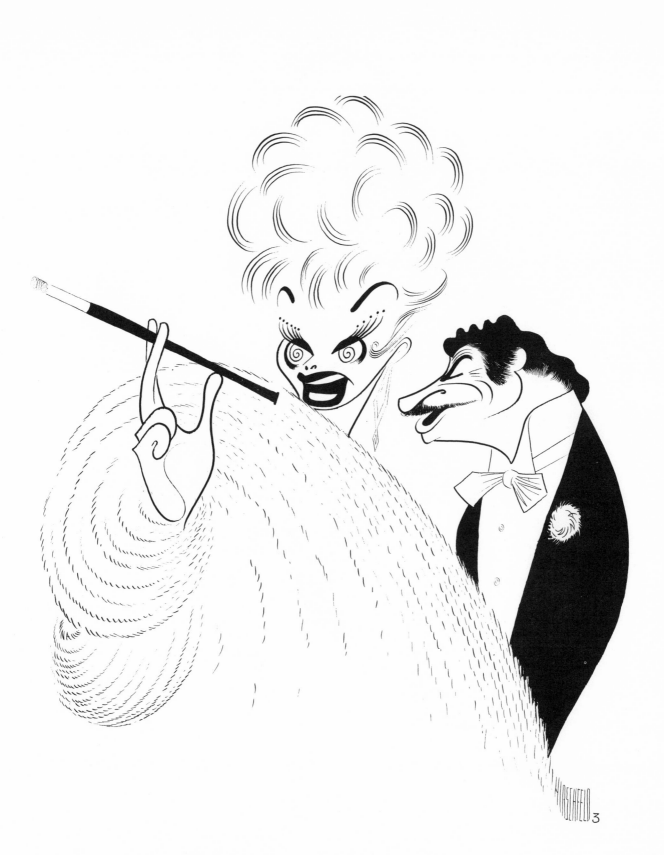

Lucille Ball and Robert Preston in "Mame"

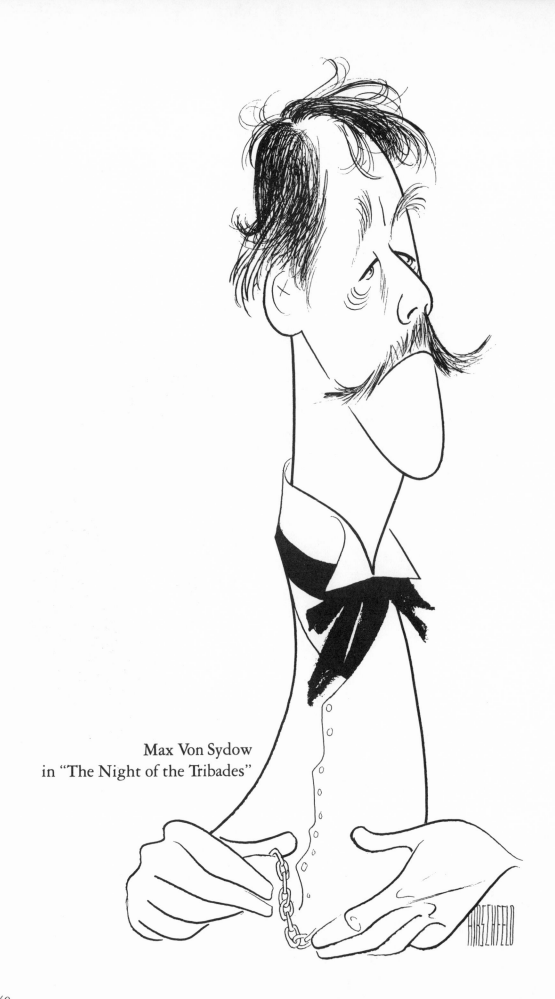

Max Von Sydow
in "The Night of the Tribades"

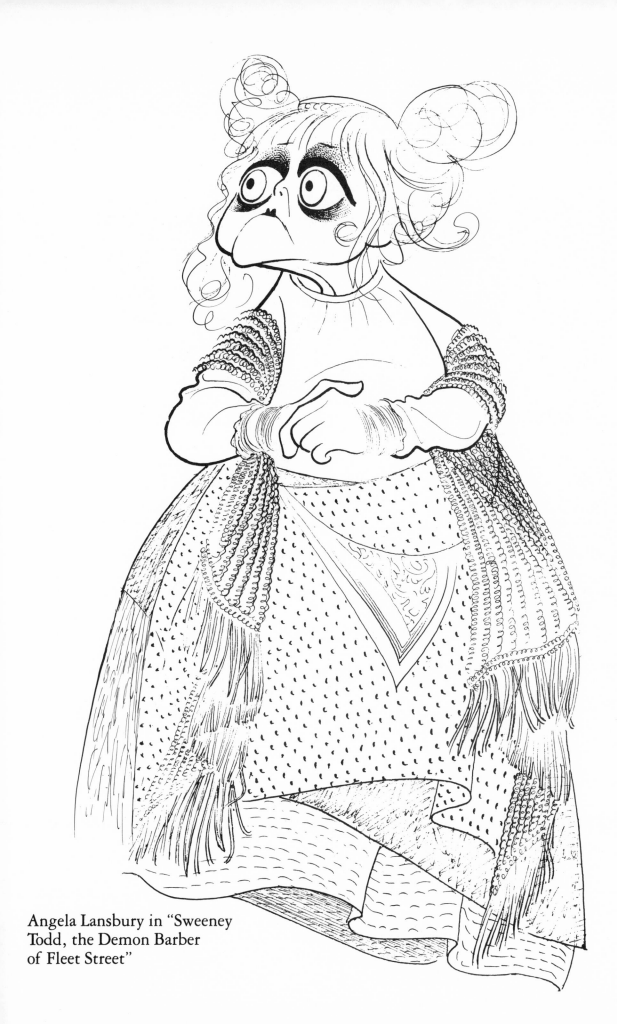

Angela Lansbury in "Sweeney
Todd, the Demon Barber
of Fleet Street"

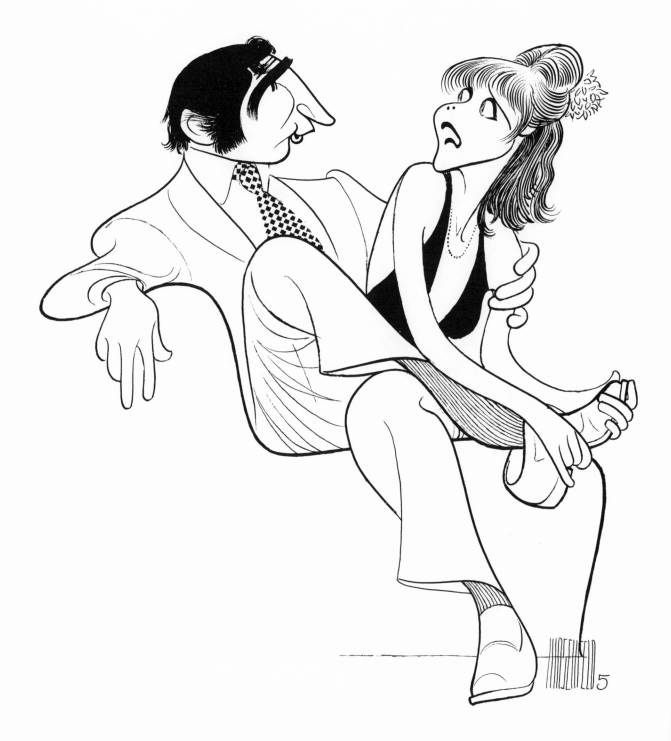

Judd Hirsch and Anita Gillette in "Chapter Two"

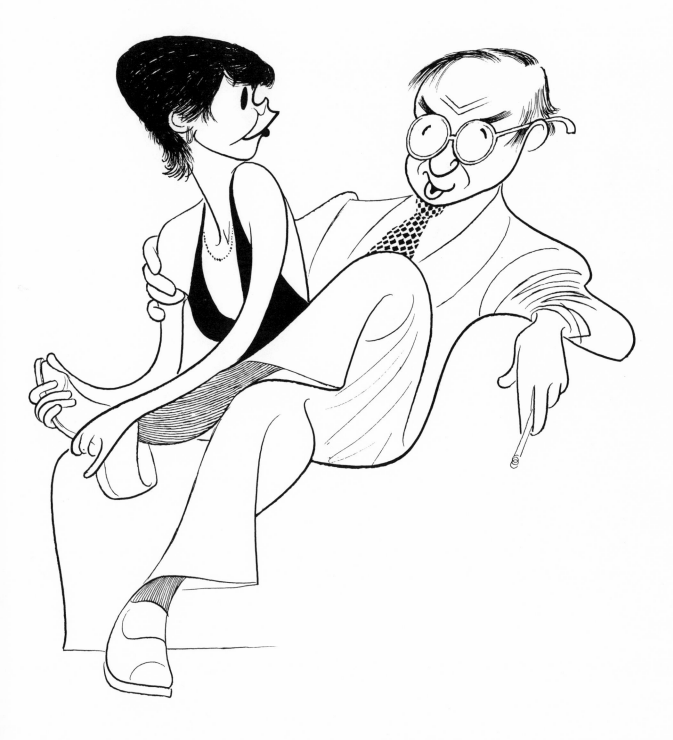

Marsha Mason and Neil Simon

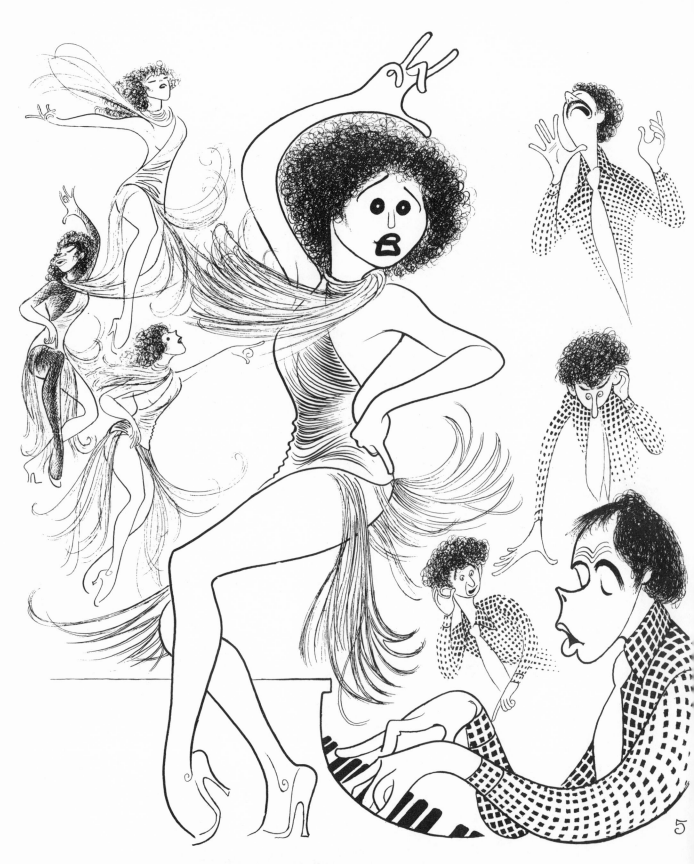

Lucie Arnaz and Robert Klein in "They're Playing Our Song"

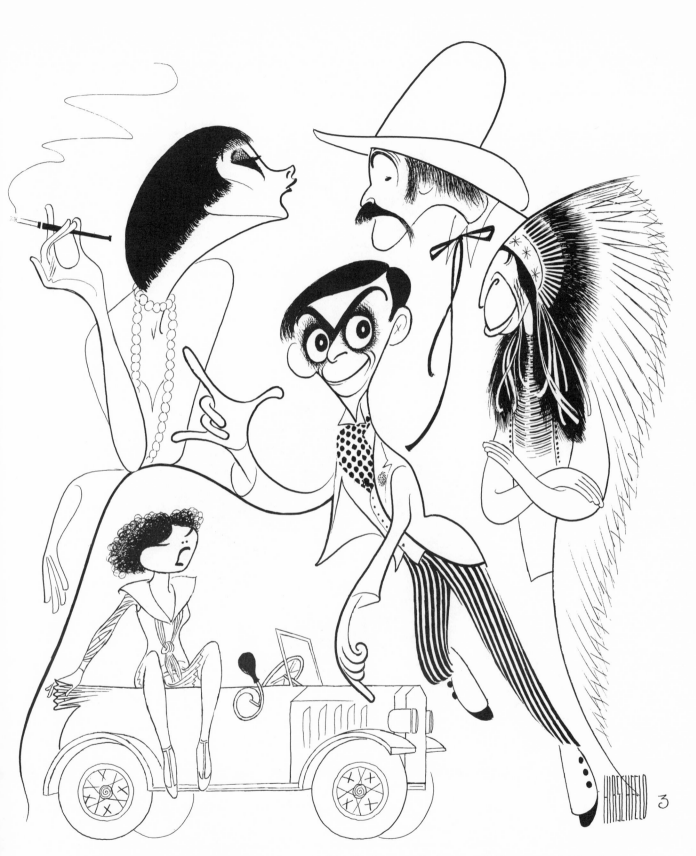

Beth Austin, Catherine Cox, J. Kevin Scannell, Leonard Drum and Charles Repole in "Whoopee!"

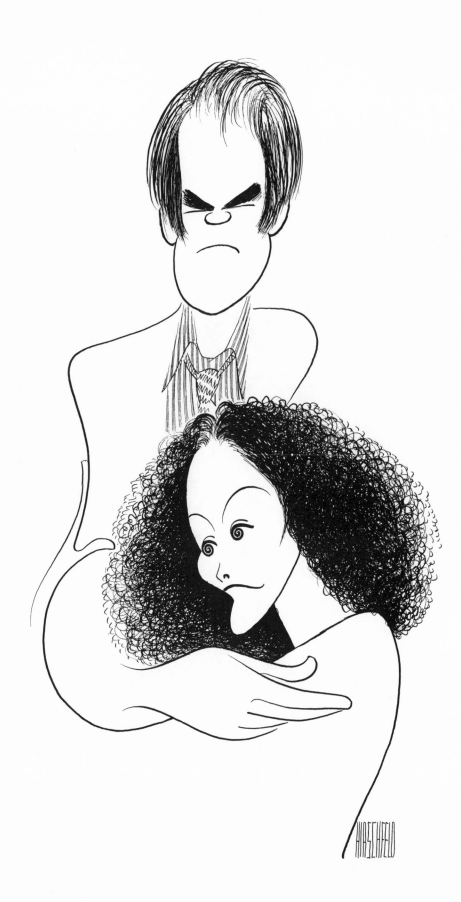

Laurence Luckinbill and Robin Strasser in "Chapter Two"

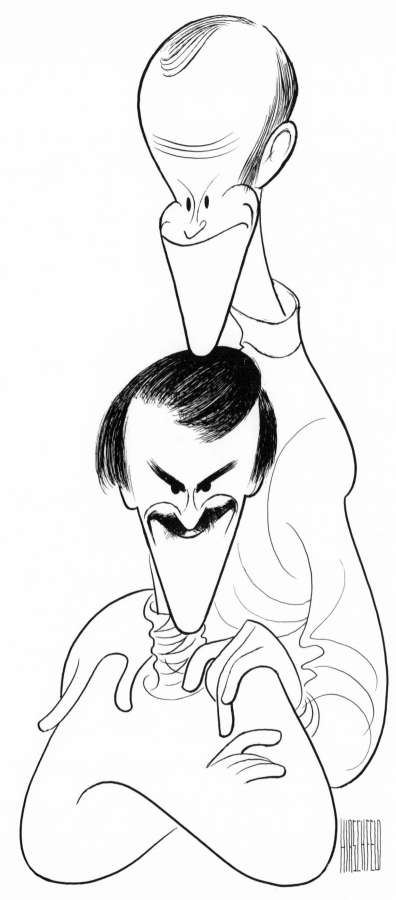

The Smothers Brothers in "I Love My Wife"

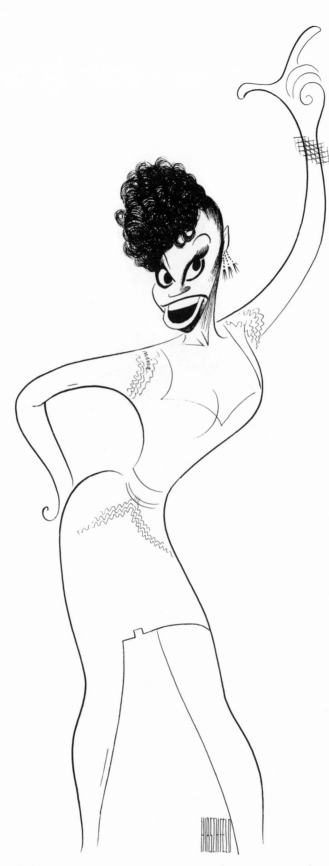

Debbie Allen in "Ain't Misbehavin'"

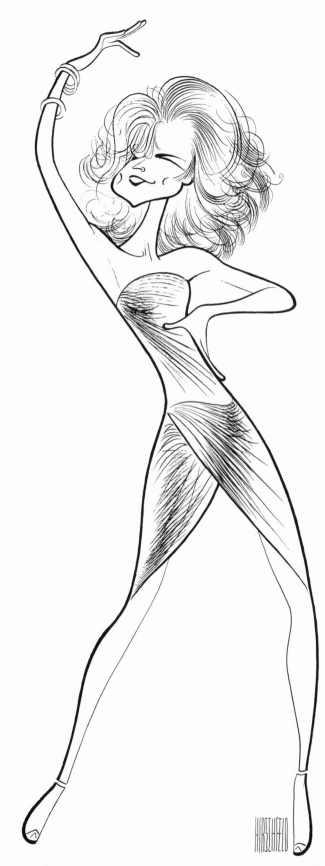

Tovah Feldshuh in "Sarava"

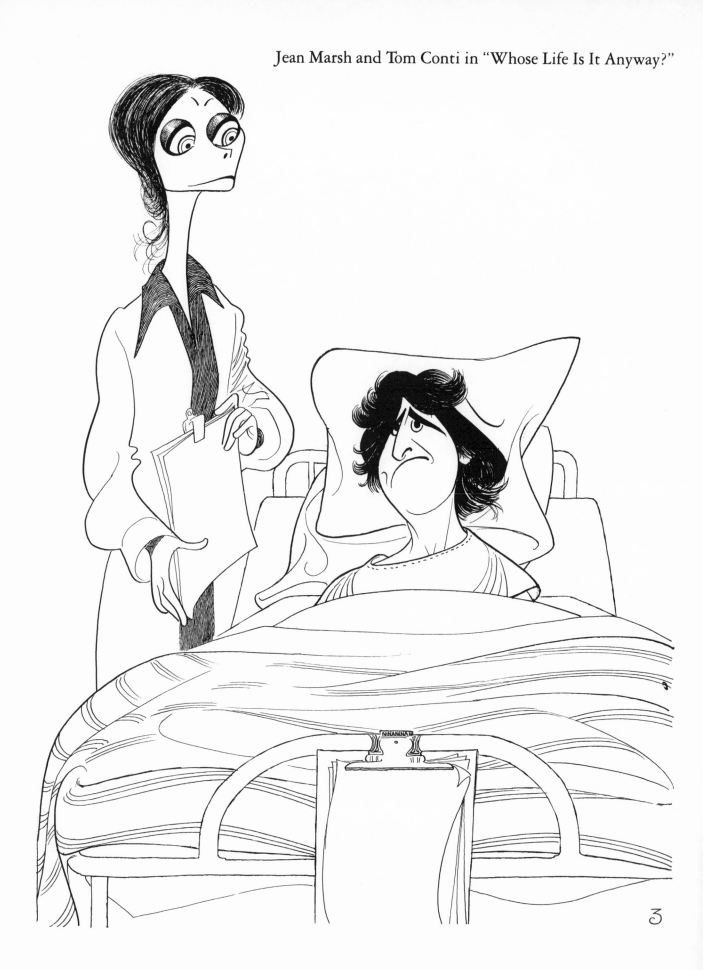

Jean Marsh and Tom Conti in "Whose Life Is It Anyway?"

Kevin Conway, Philip Anglim and Carole Shelley in "The Elephant Man"

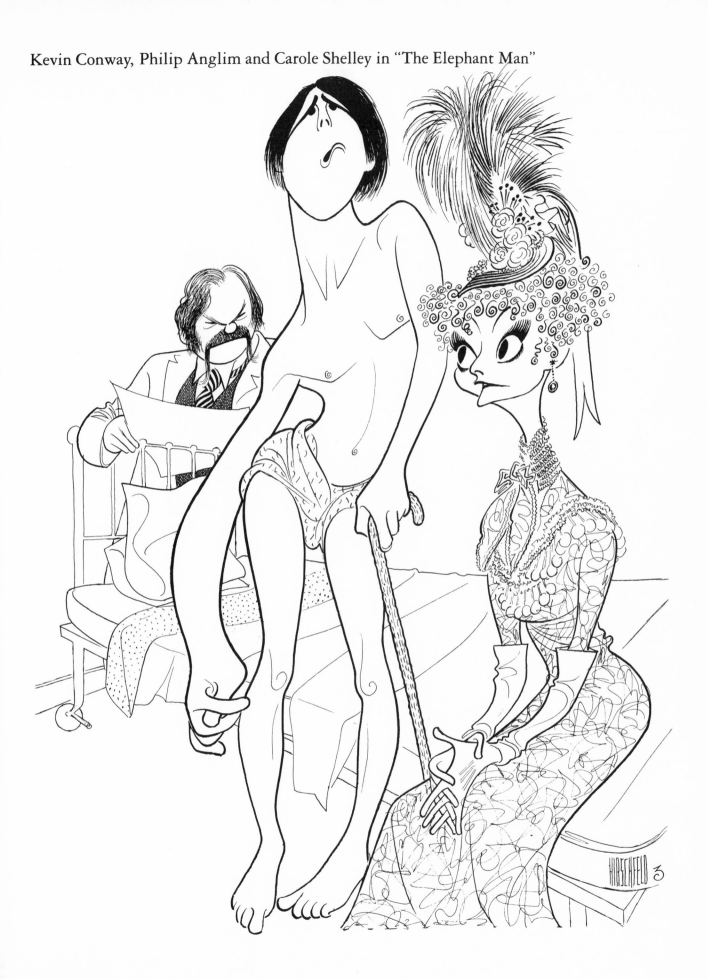

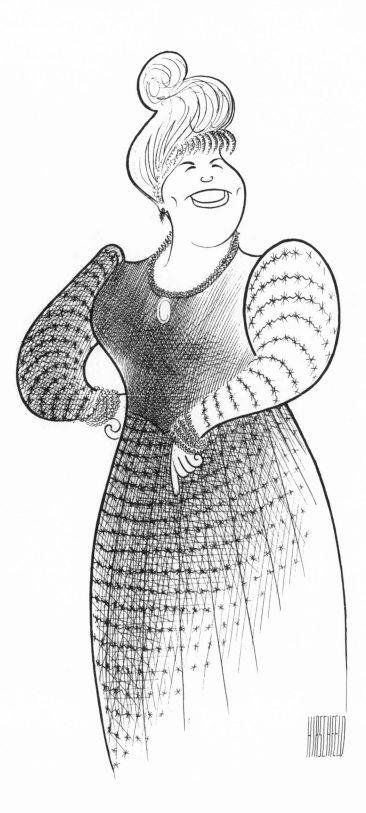

Kathleen Freeman in "13 Rue de l'Amour"

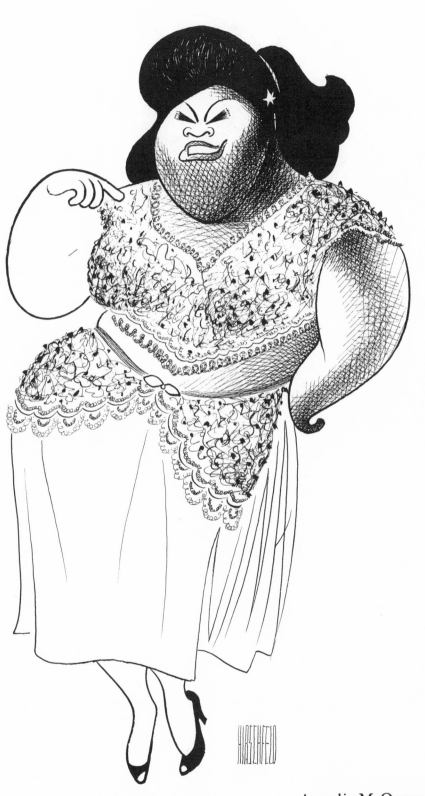

Armelia McQueen
in "Ain't Misbehavin'"

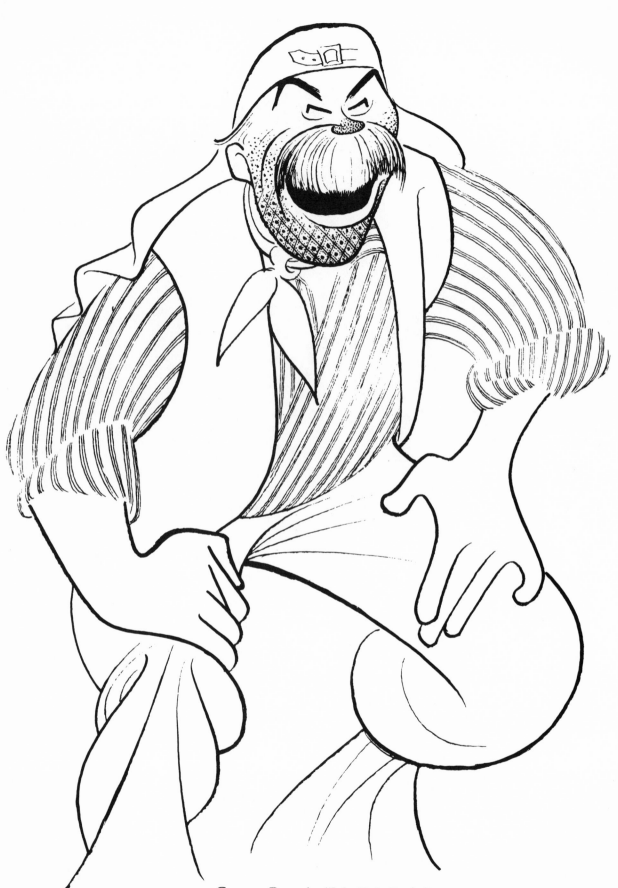

George Rose in "My Fair Lady"

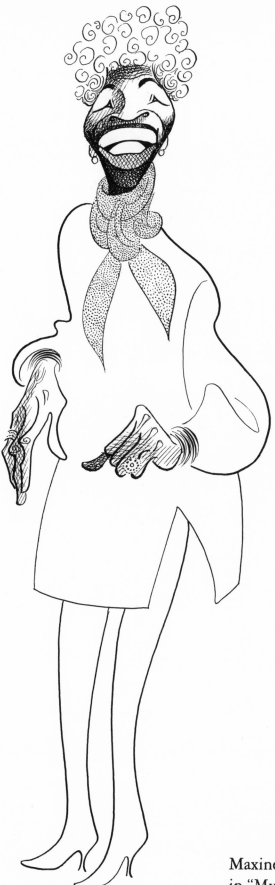

Maxine Sullivan
in "My Old Friends"

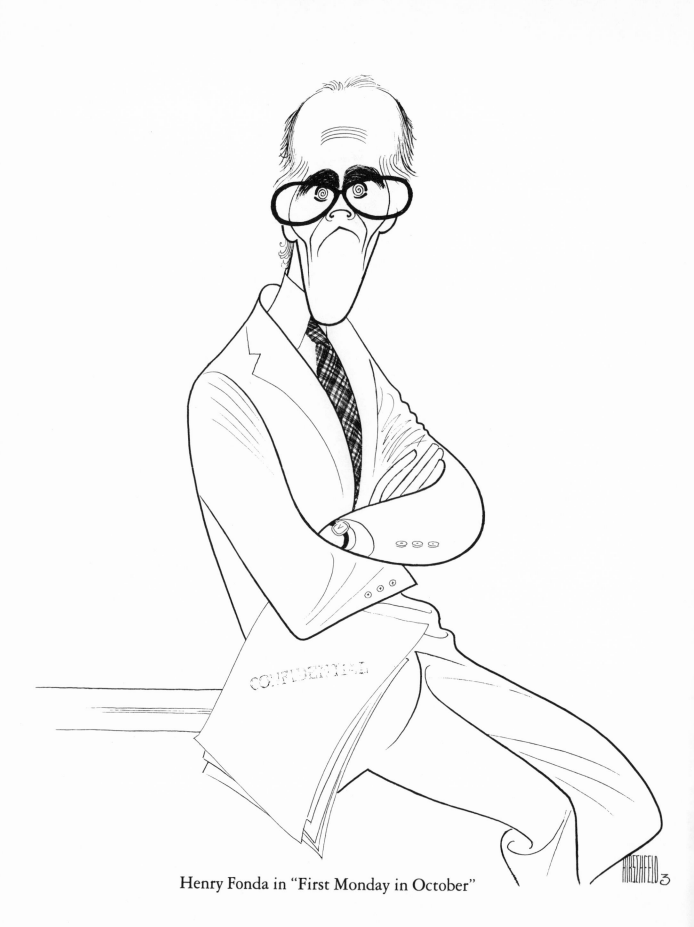

Henry Fonda in "First Monday in October"

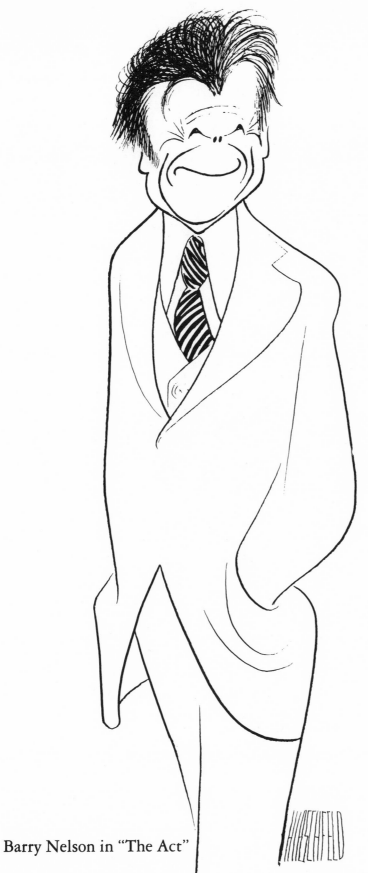

Barry Nelson in "The Act"

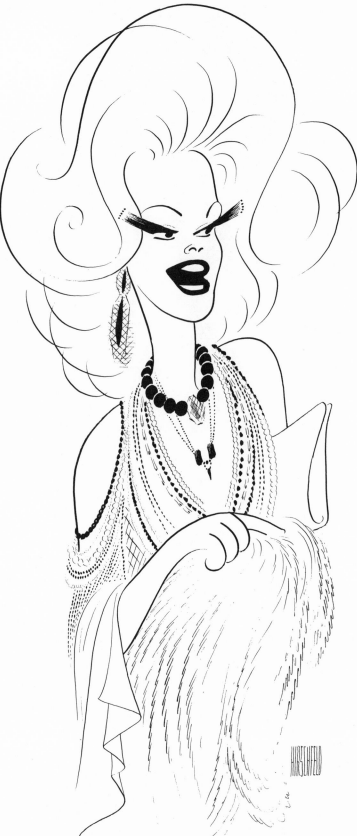

Jayne Meadows
in "Once in a Lifetime"

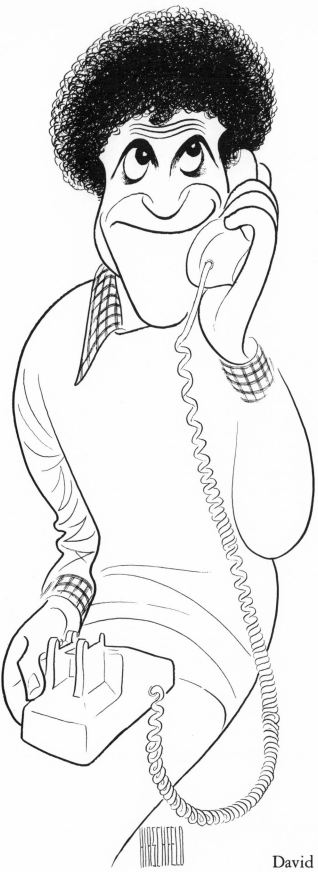

David Groh in "Chapter Two"

Douglas Turner Ward in "The Brownsville Raid"

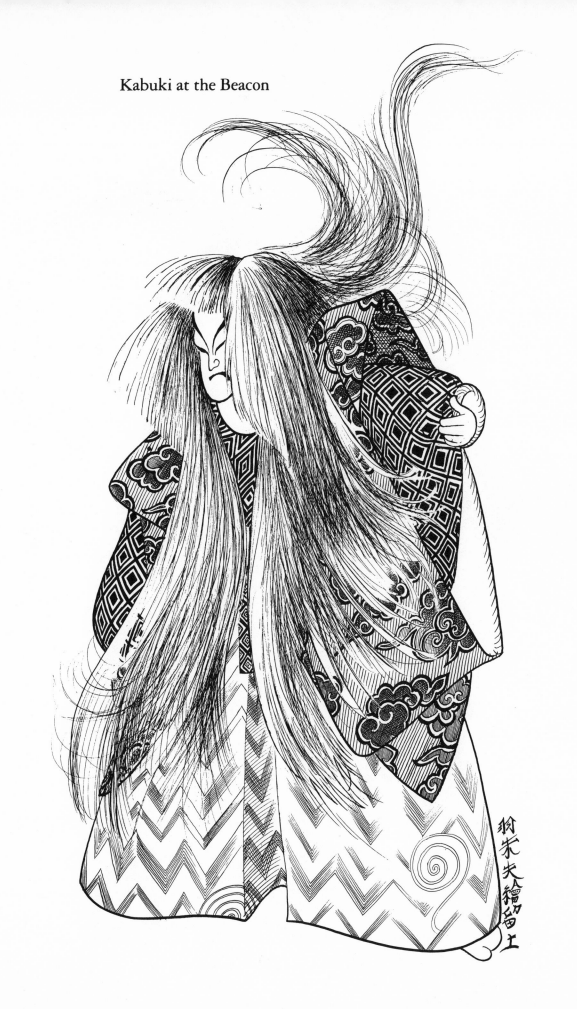

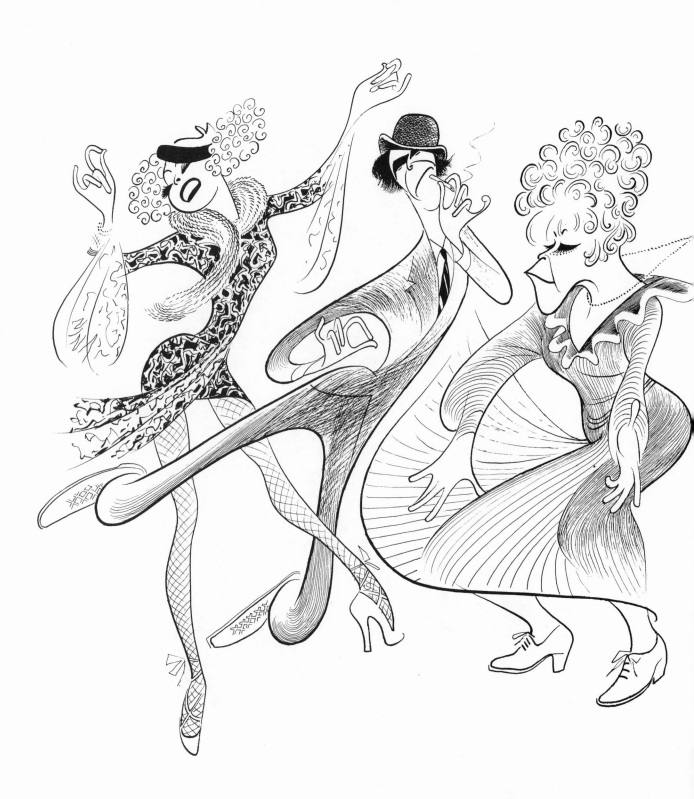

Barbara Erwin, Robert Fitch, Dorothy Loudon,

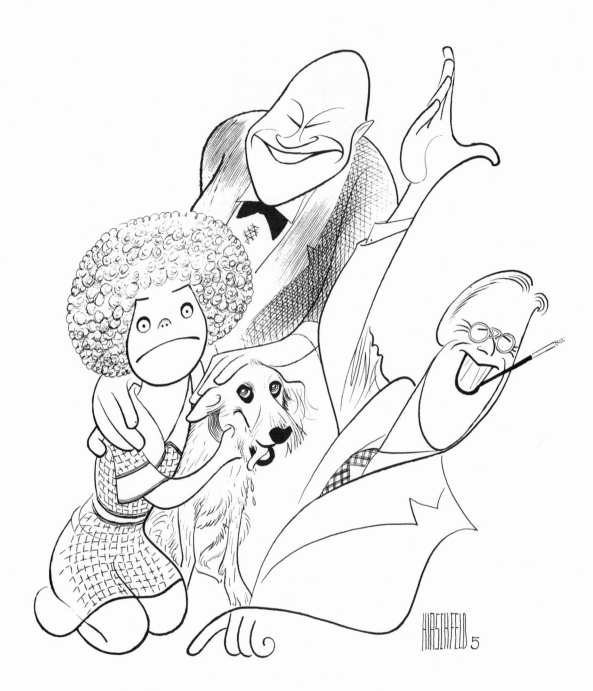

Andrea McArdle, Sandy, Reid Shelton and Raymond Thorne in "Annie"

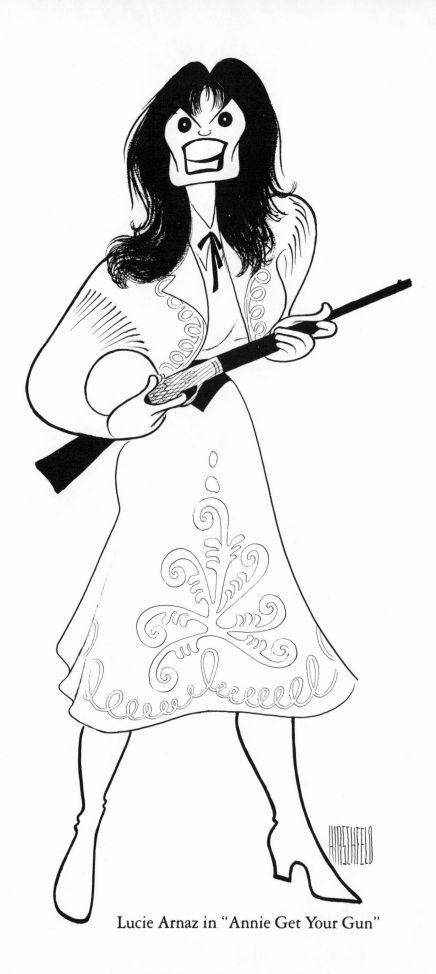

Lucie Arnaz in "Annie Get Your Gun"

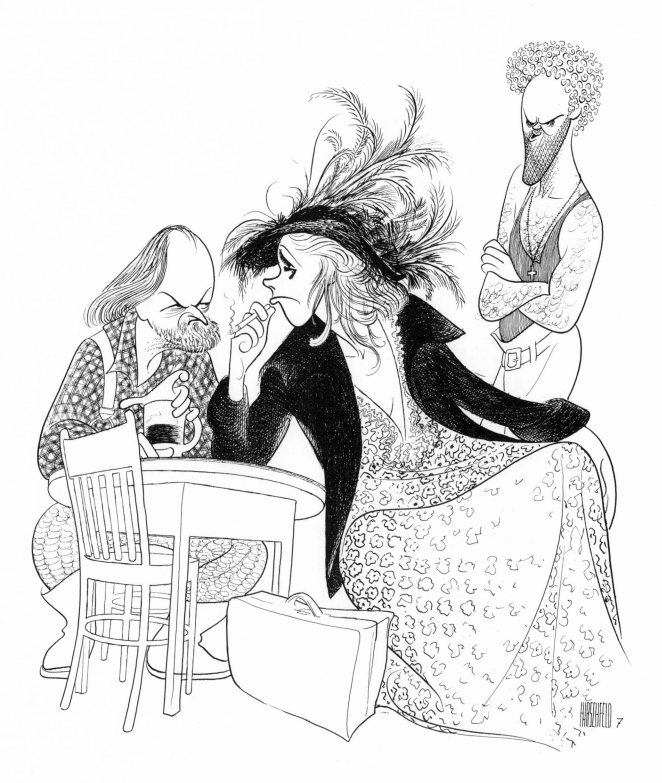

Robert Donley, Liv Ullmann and John Lithgow in "Anna Christie"

Nancy Donohue
in "The Runner Stumbles"

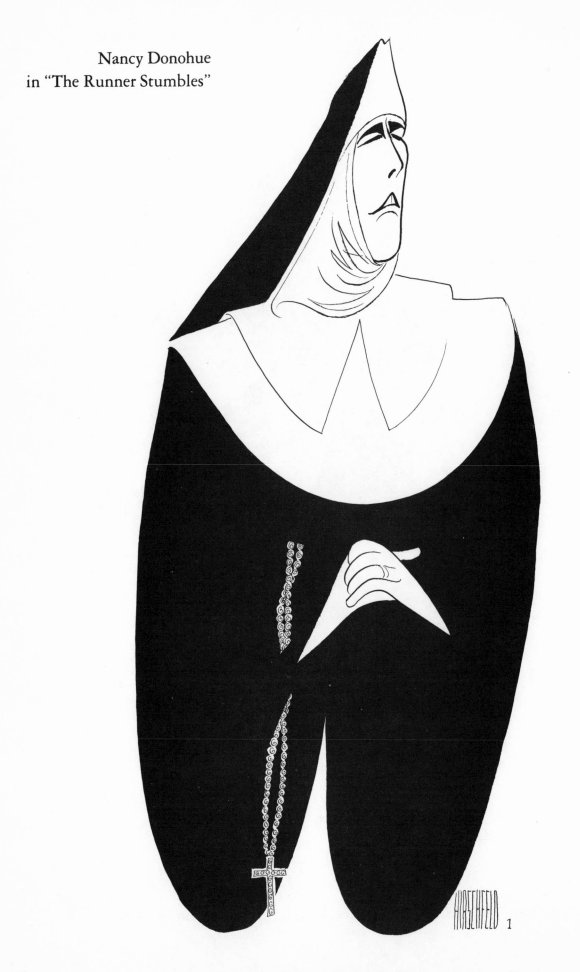

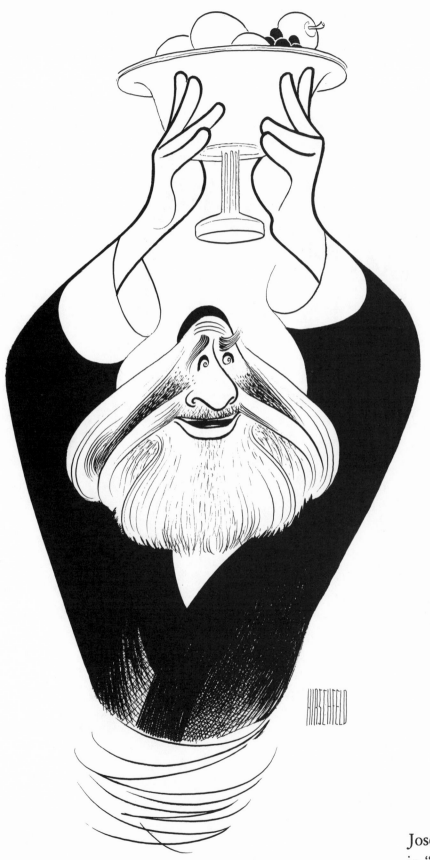

Joseph Leon
in "The Merchant"

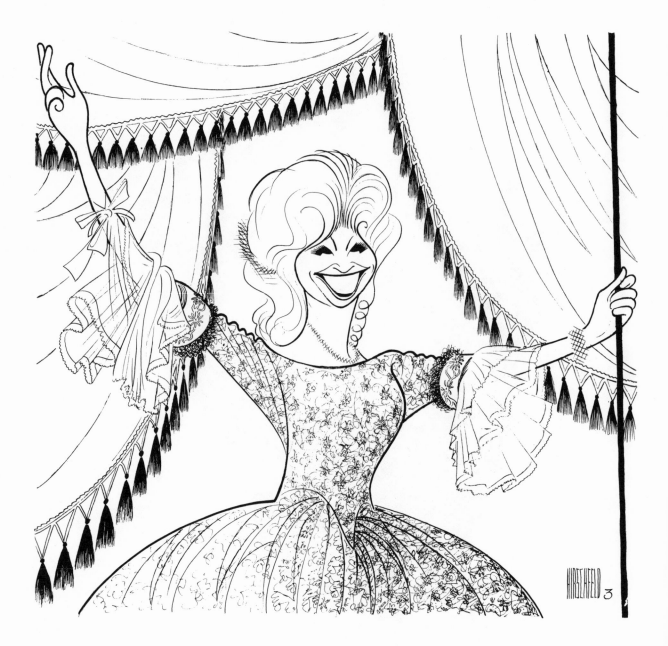

Beverly Sills

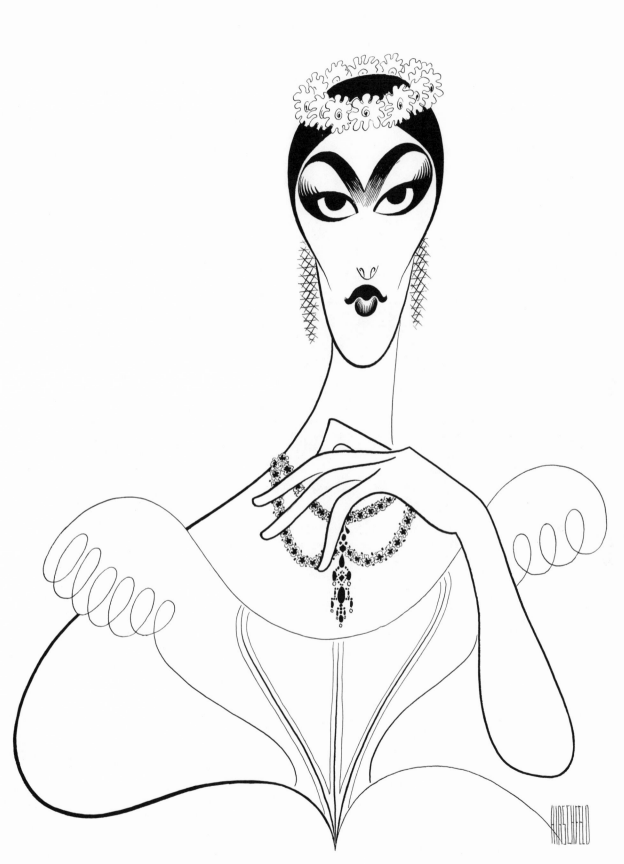

Maria Callas

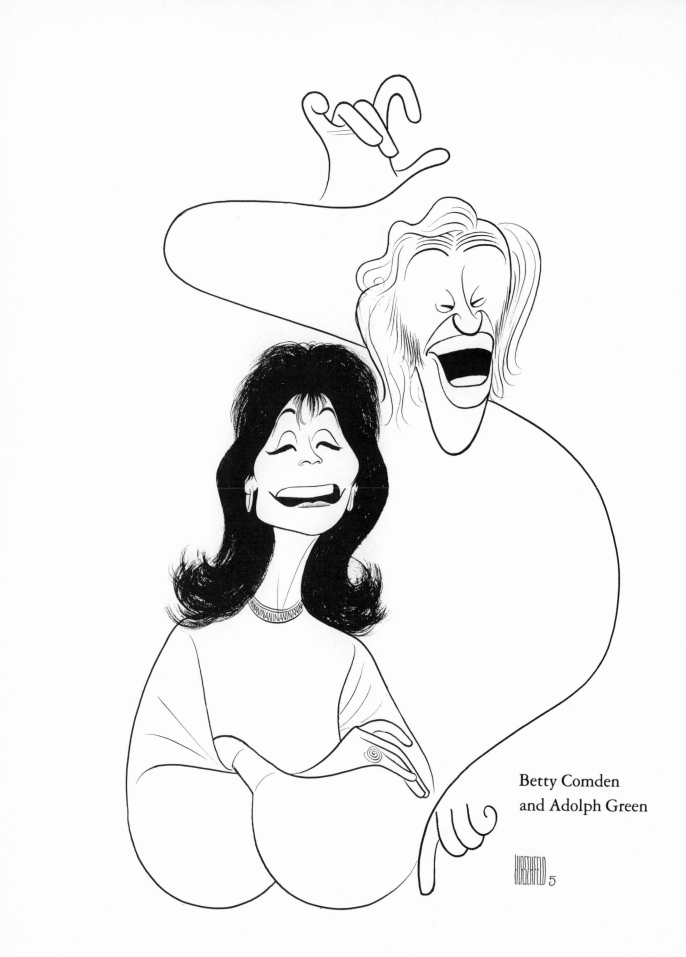

Betty Comden
and Adolph Green

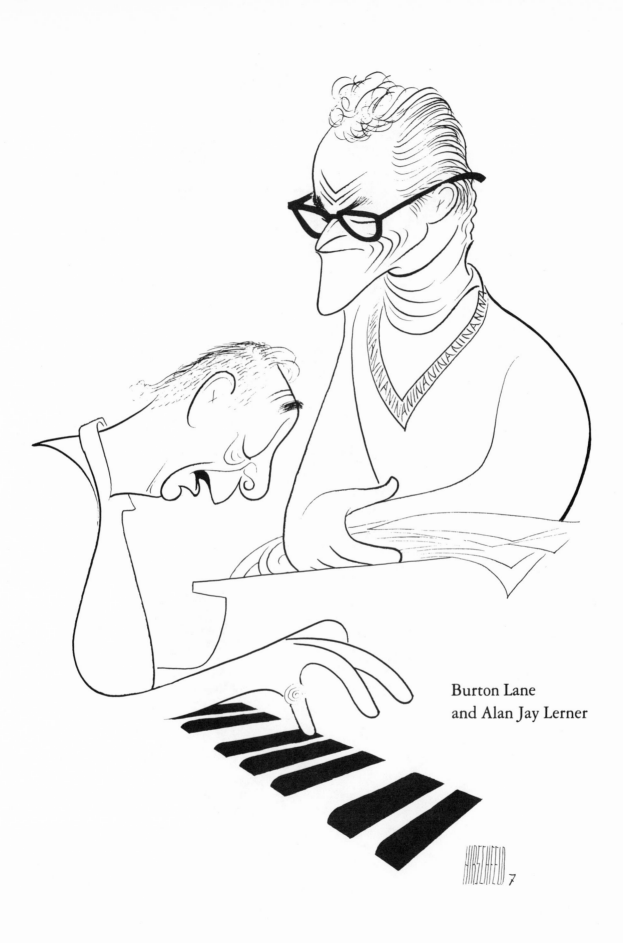

Burton Lane
and Alan Jay Lerner

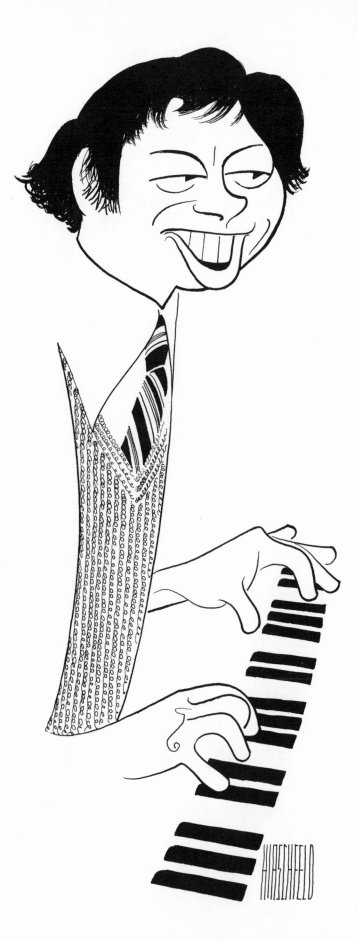

Cy Coleman

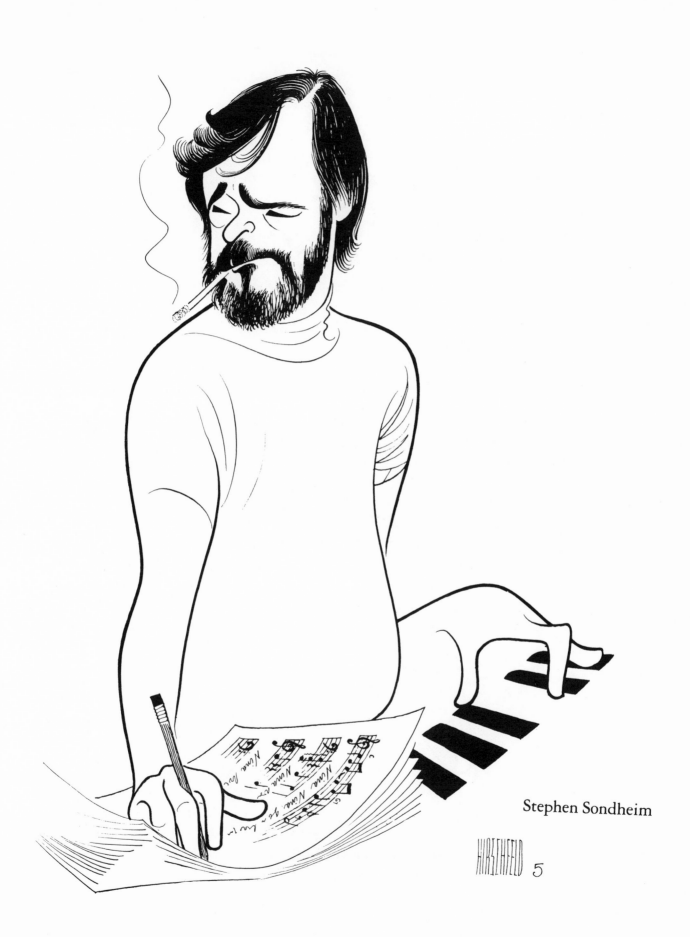

Stephen Sondheim

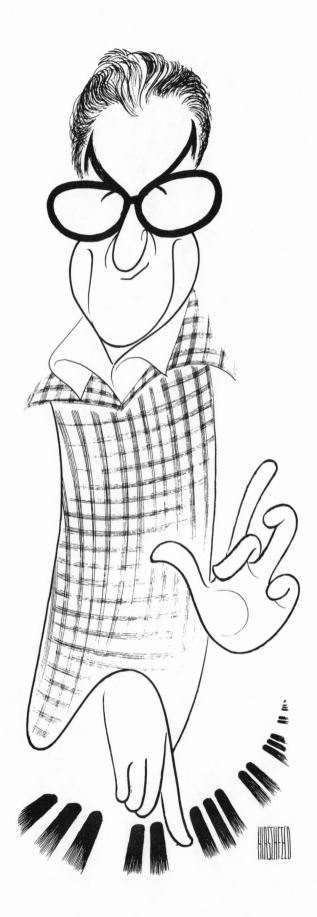

Harold Rome

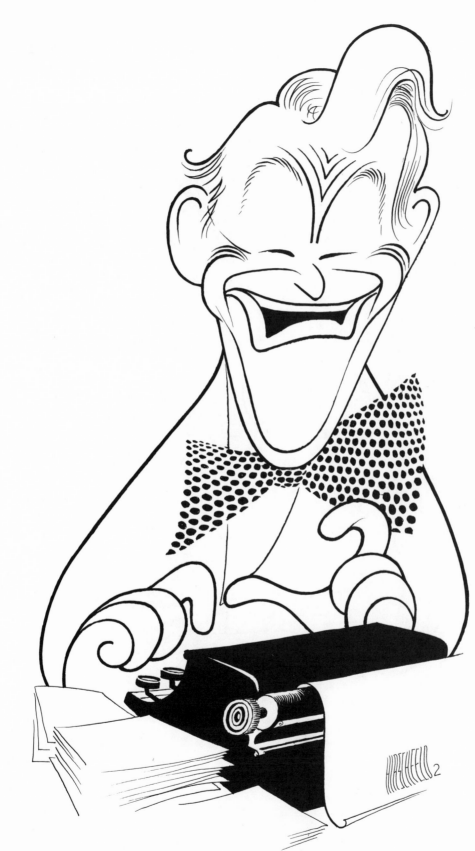

Yip Harburg

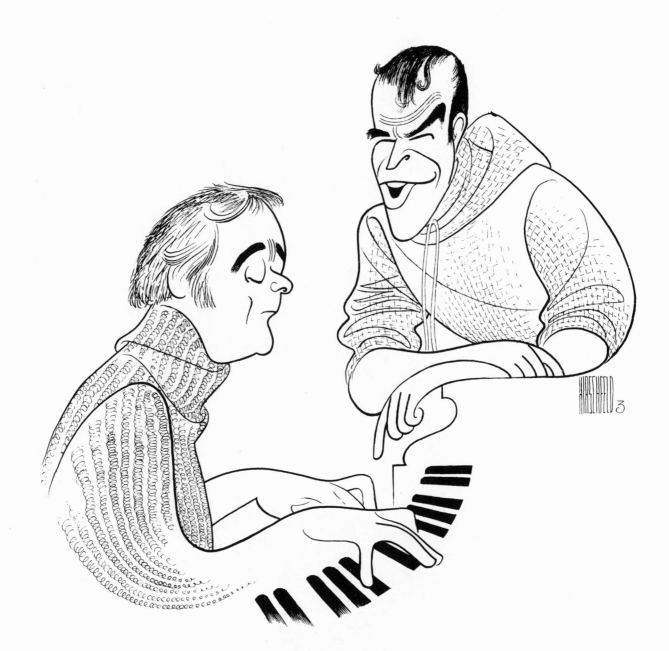

John Kander and Fred Ebb

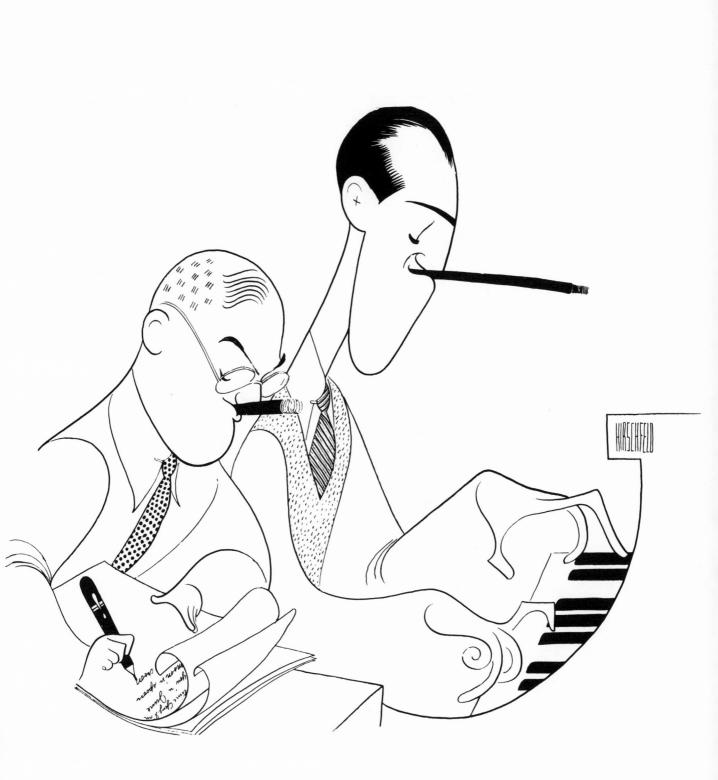

George and Ira Gershwin

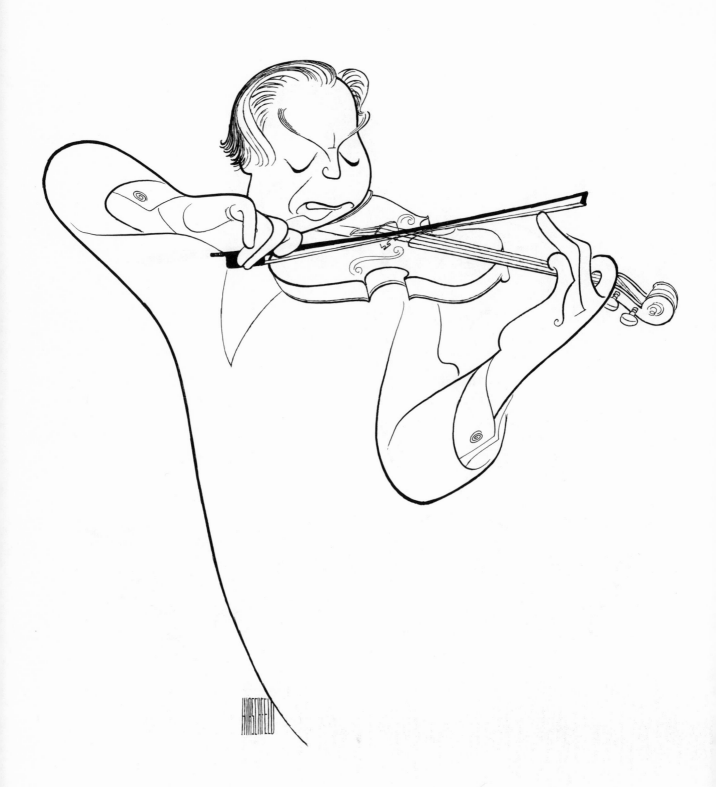

Isaac Stern

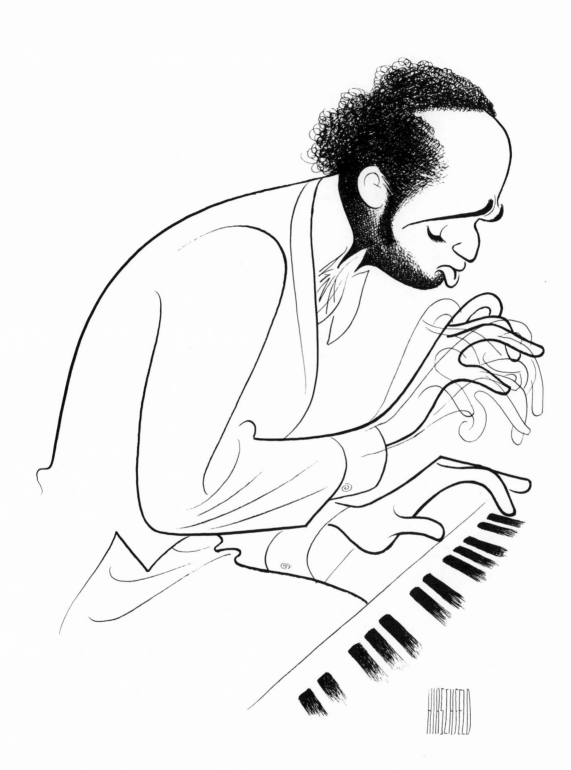

André Watts

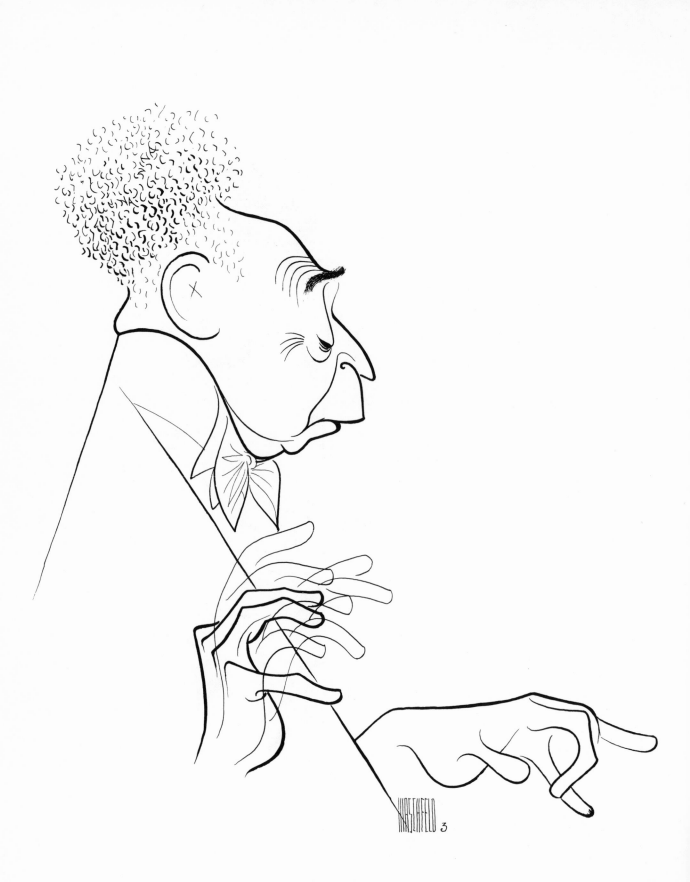

Artur Rubinstein

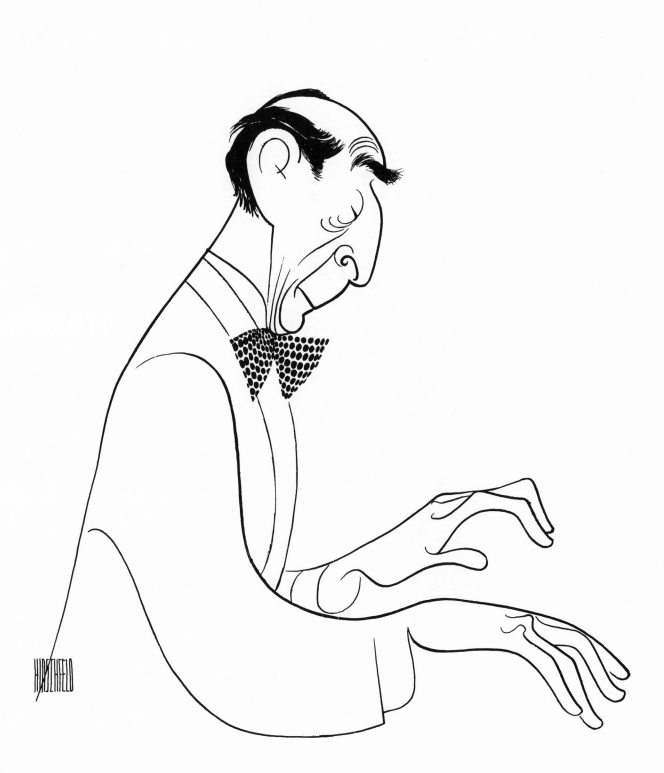

Vladimir Horowitz

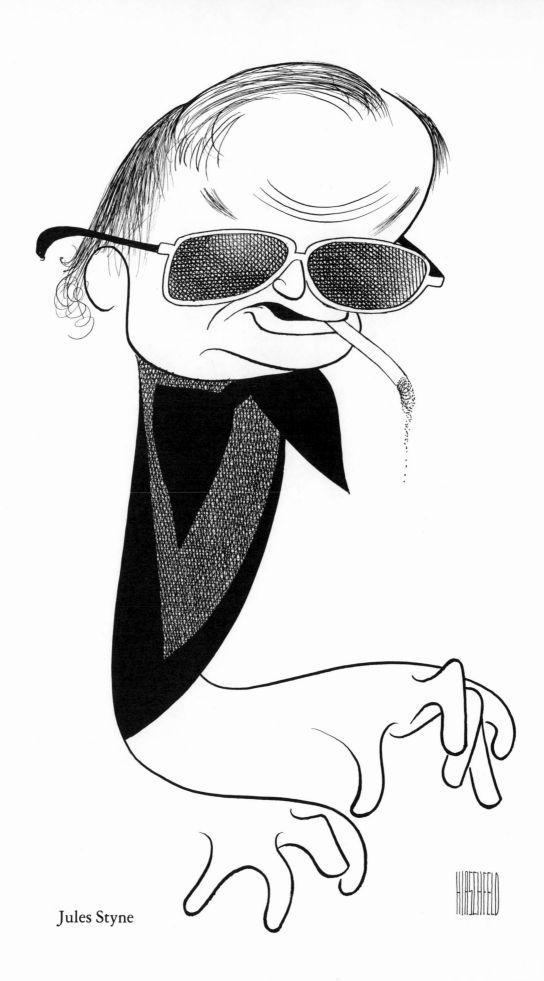

Jules Styne

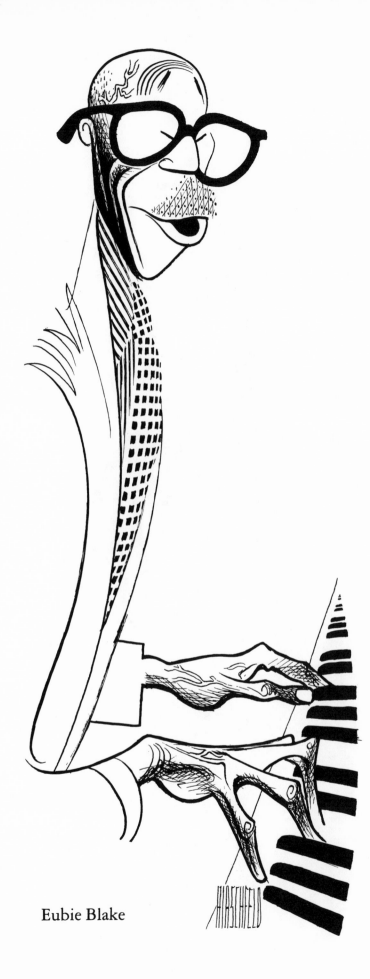

Eubie Blake

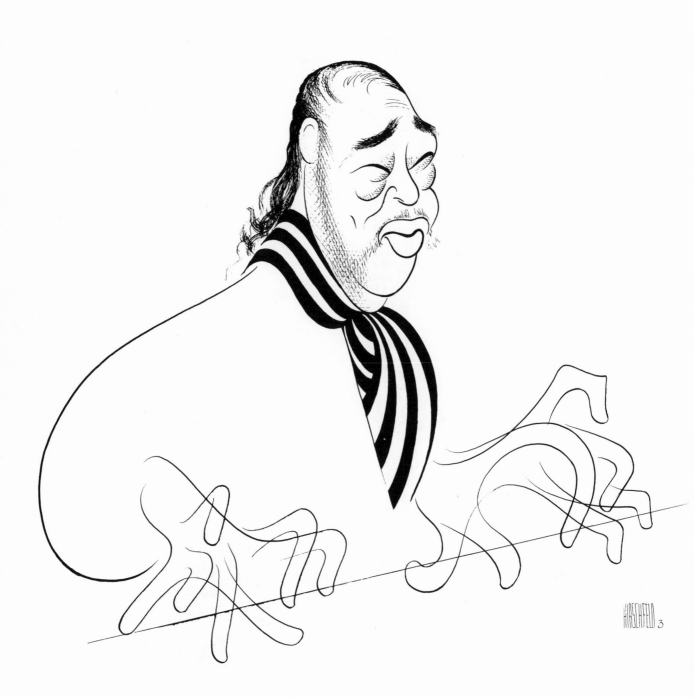

Duke Ellington

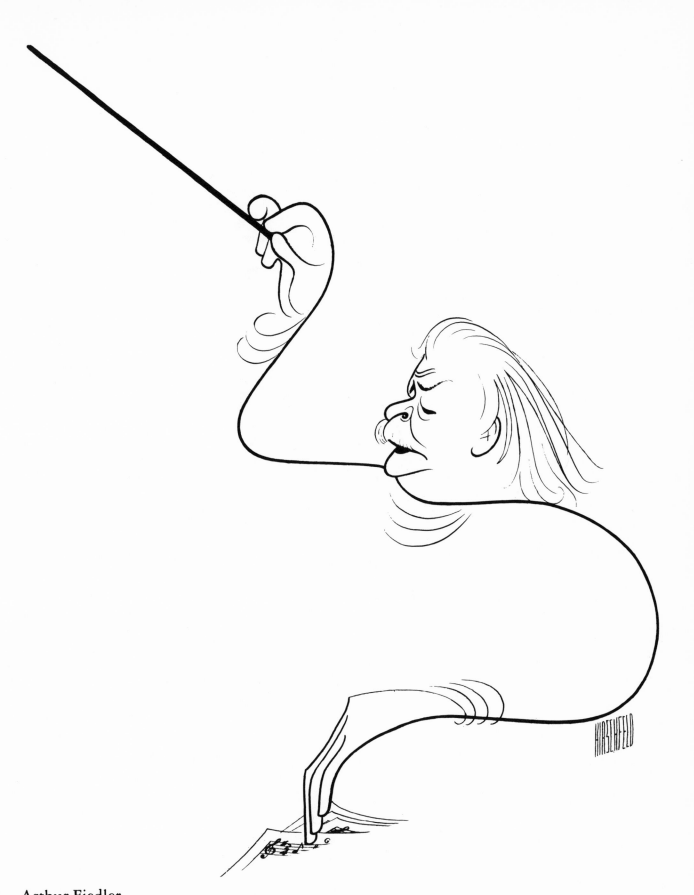

Arthur Fiedler

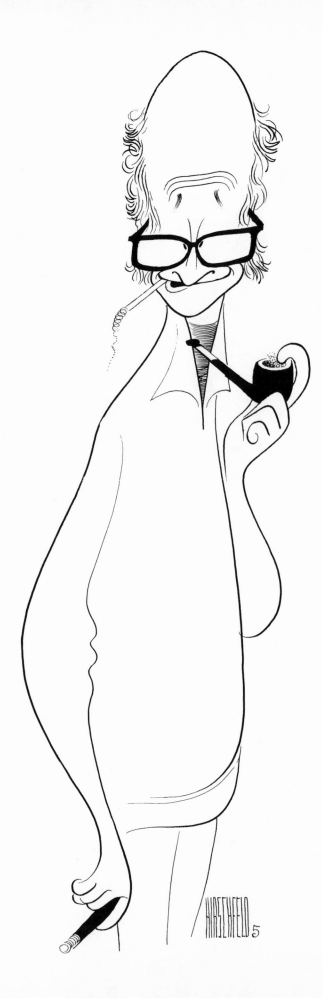

Jules Feiffer

Arthur Miller

Lee Strasberg

Boris Aronson

Abe Burrows

Mike Nichols

Harold Prince

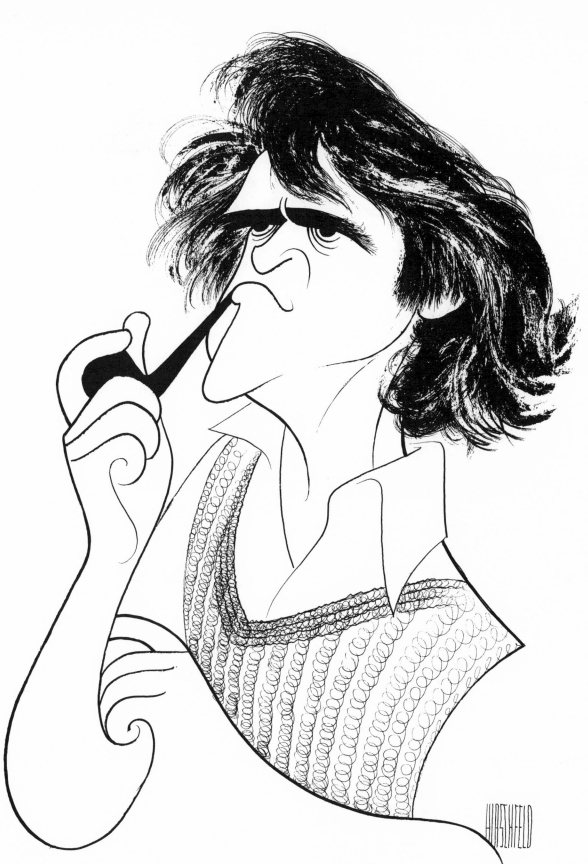

Joseph Papp

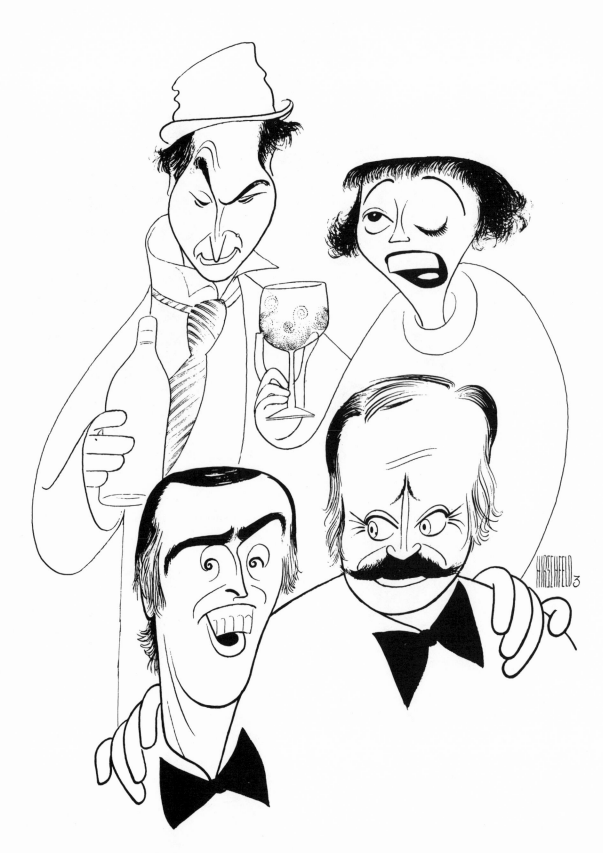

Sid Caesar, Imogene Coca and Rowan and Martin

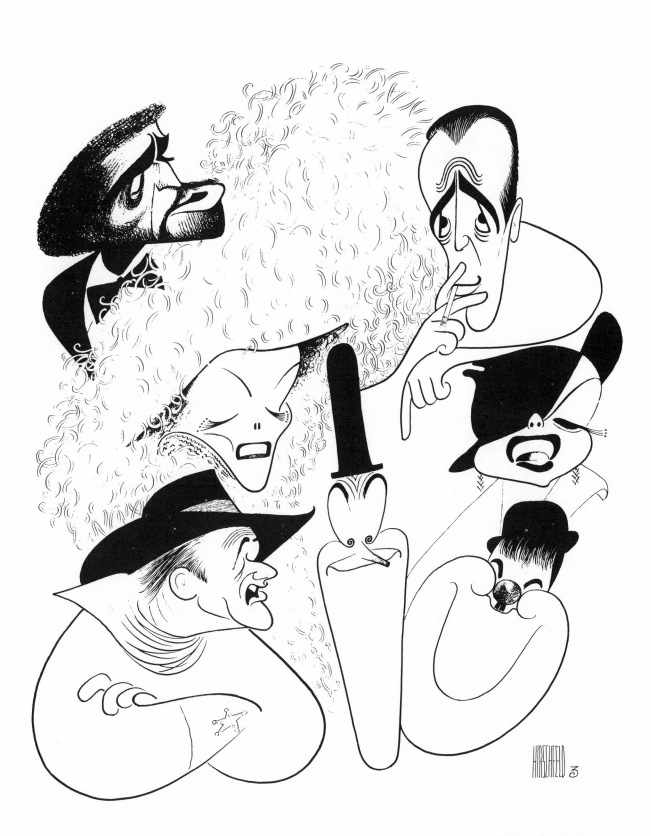

Sammy Davis, Jr., Humphrey Bogart, Judy Garland, Laurel and Hardy, John Wayne and Katharine Hepburn

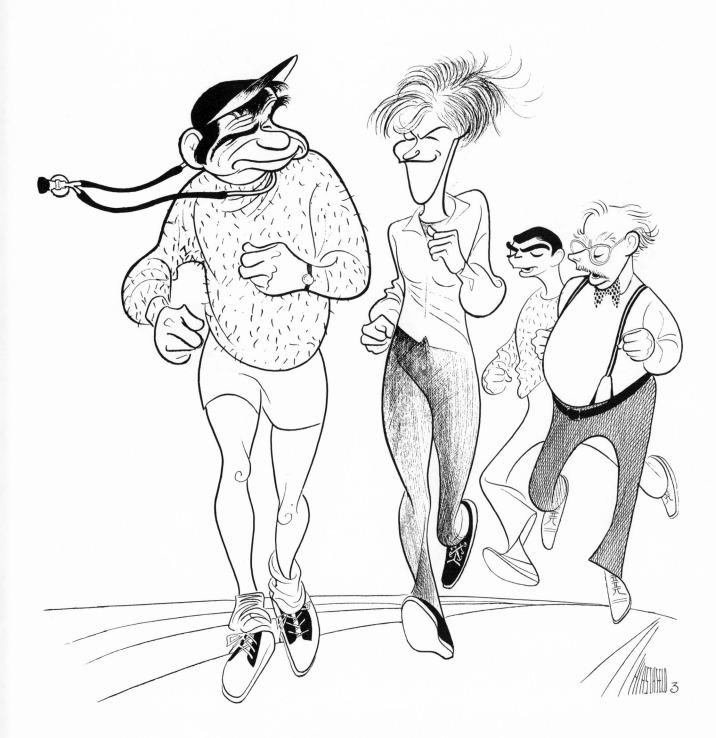

Walter Matthau, Glenda Jackson, Richard Benjamin and Art Carney in "House Calls"

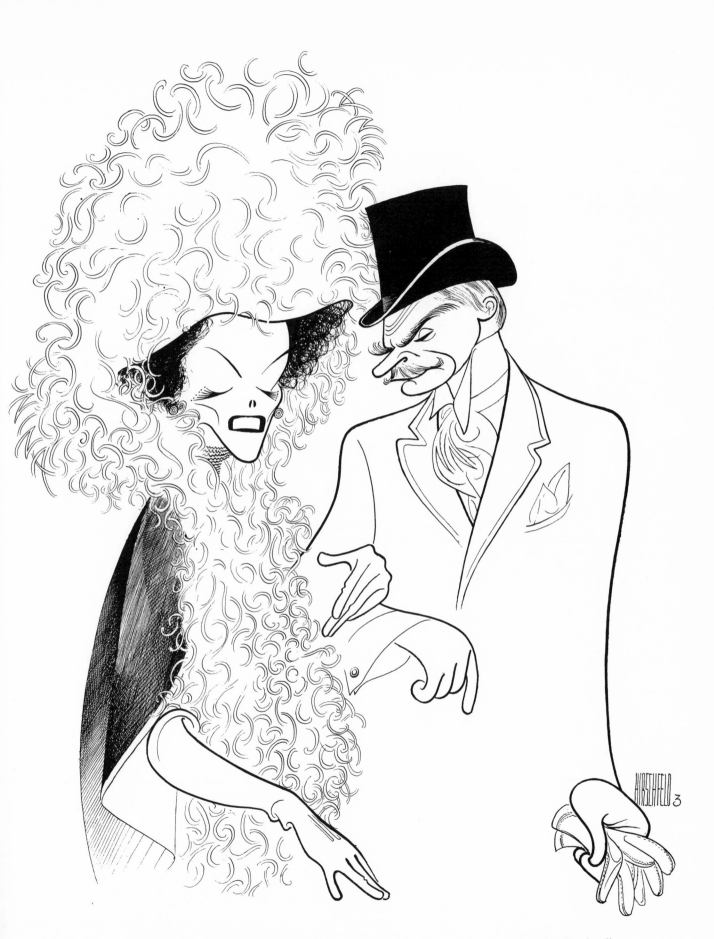

Katharine Hepburn and Laurence Olivier in "Love Among the Ruins"

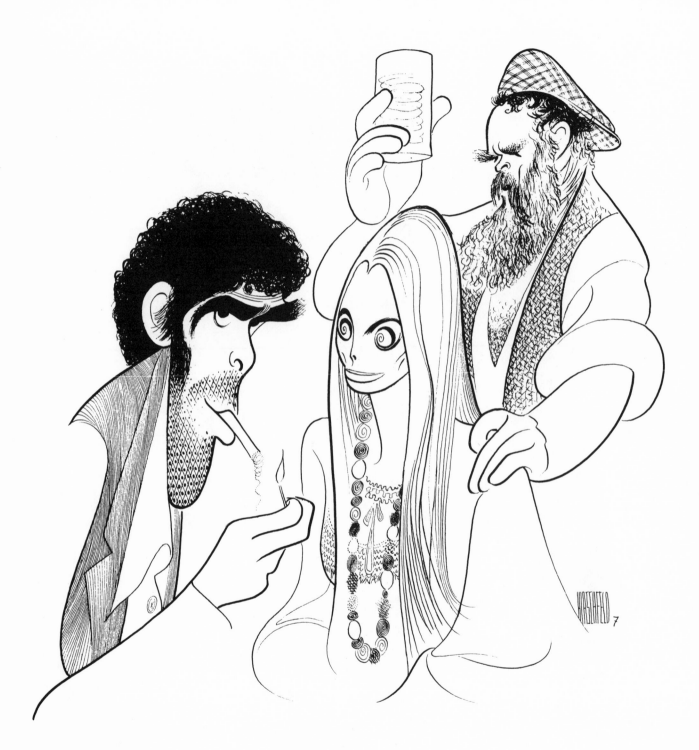

Elliot Gould, Nina Von Pallandt and Sterling Hayden in "The Long Goodbye"

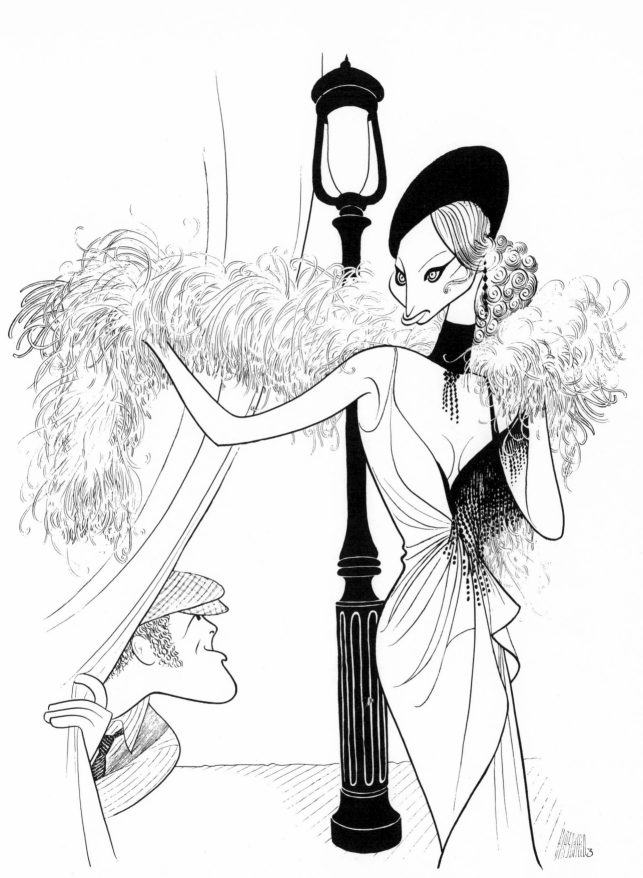

Barbra Streisand and James Caan in "Funny Lady"

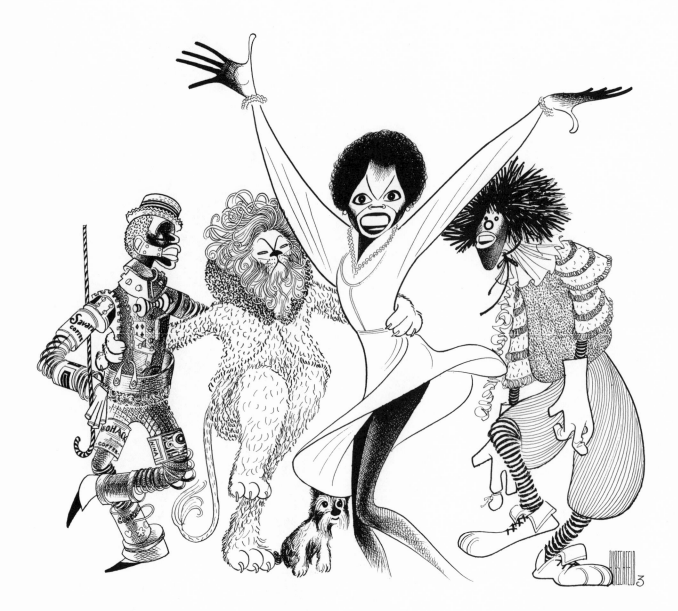

Diana Ross and friends in "The Wiz"

Marsha Mason, Richard Dreyfuss and Quinn Cummings in "The Goodbye Girl"

Alan Alda, Jane Fonda, Bill Cosby, Richard Pryor, Elaine May, Walter Matthau, Michael Caine and Maggie Smith in "California Suite"

Walter Matthau and Jack Lemmon in "The Odd Couple"

Carol Burnett, Jack Lemmon, Walter Matthau and Billy Wilder (director) of "The Front Page"

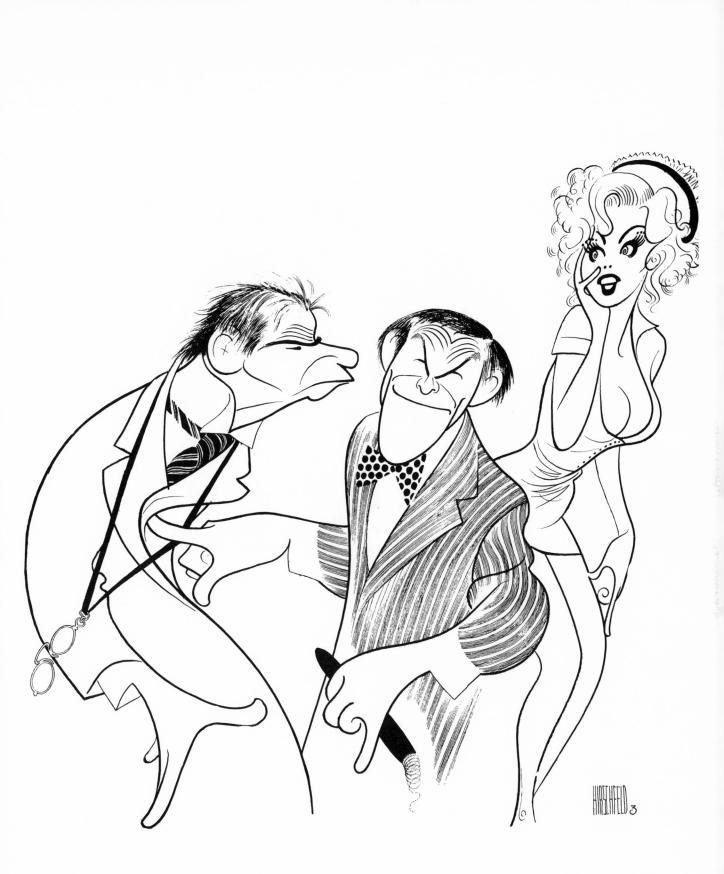

Walter Matthau, George Burns and a blonde nurse in "The Sunshine Boys"

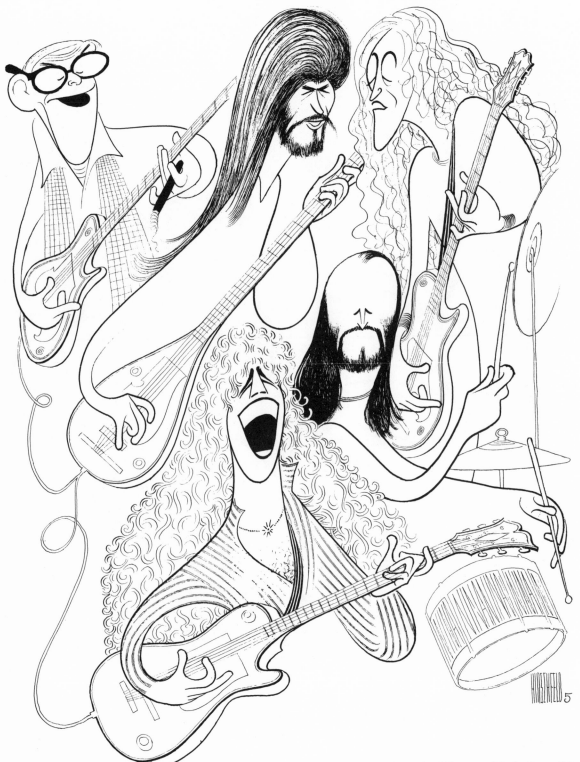

George Burns and the Bee Gees in "Sergeant Pepper's Lonely Hearts Club Band"

Aerosmith

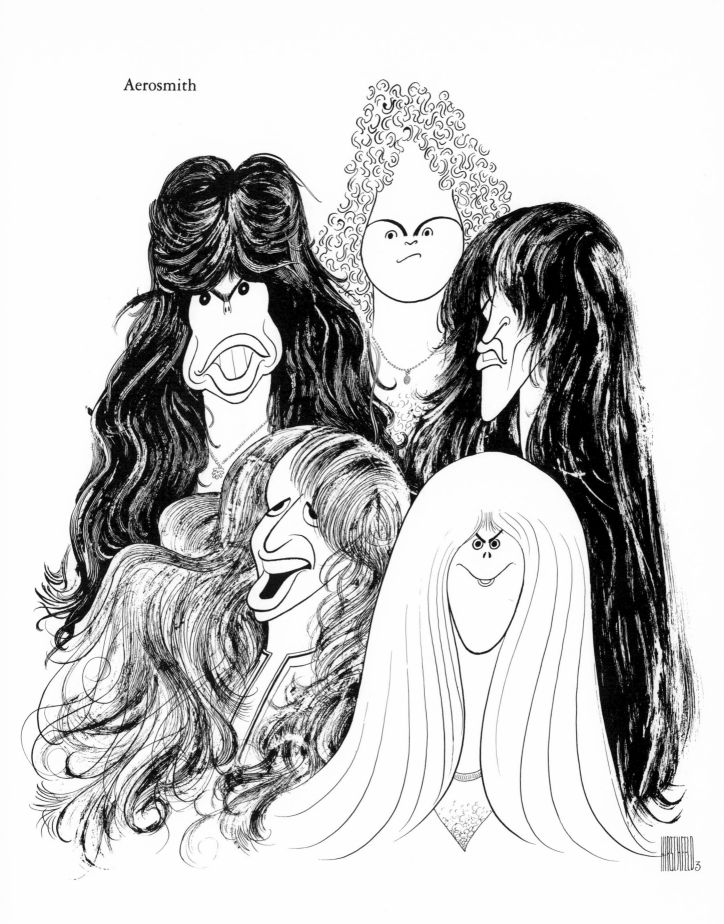

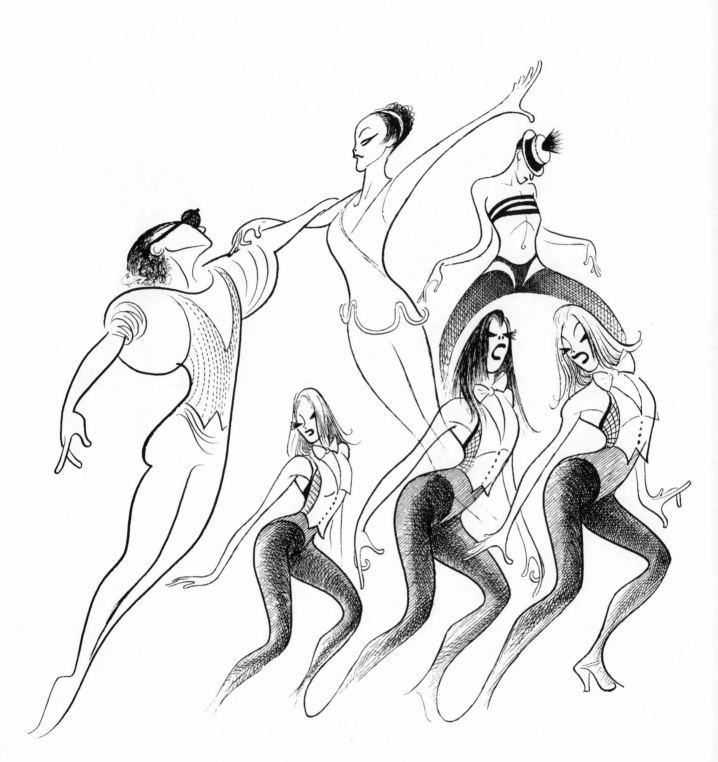

Some of the dances in "Dancin'"

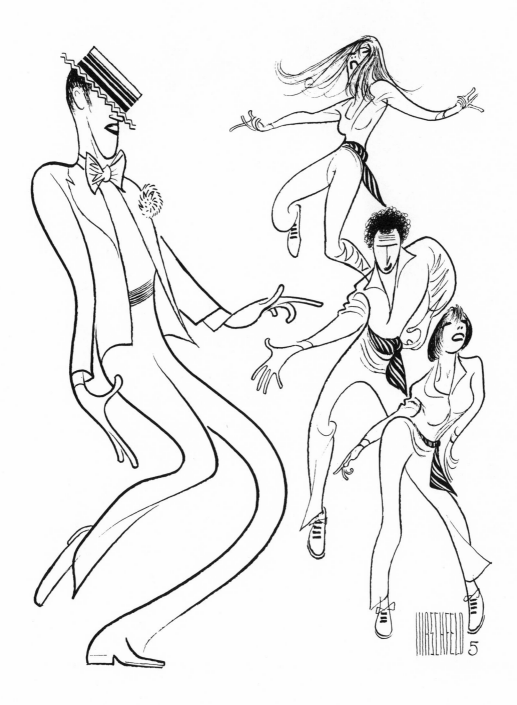

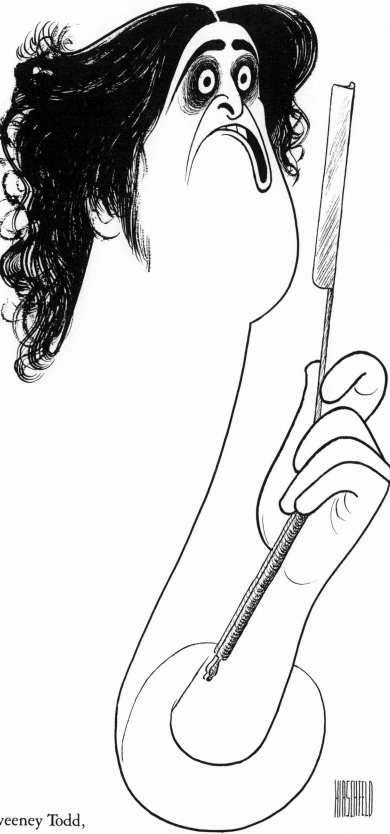

Len Cariou in "Sweeney Todd,
the Demon Barber of Fleet Street"

Donal Donnelly
in "The Faith Healer"

Geraldine Page in "Angela"

Sandy Dennis in "Daphne in Cottage D"

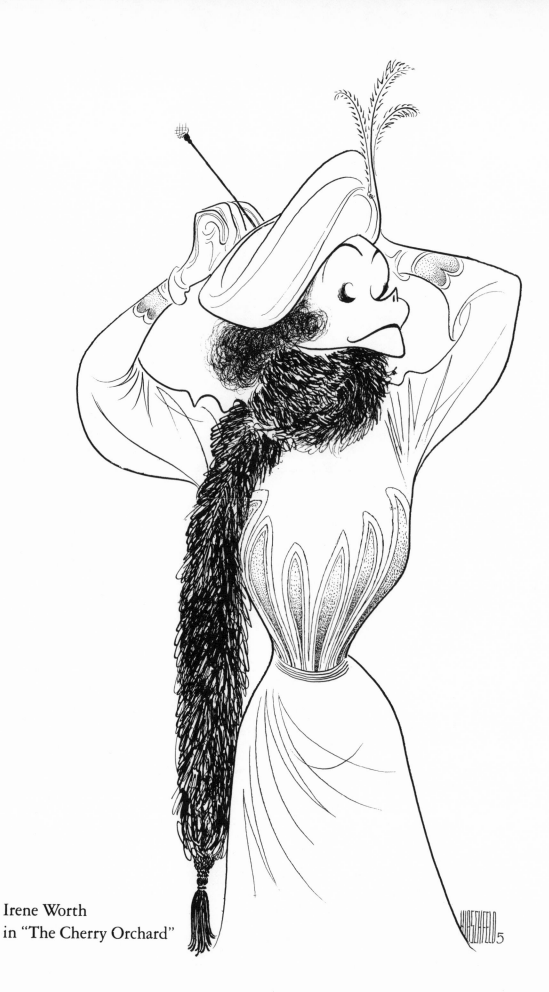

Irene Worth
in "The Cherry Orchard"

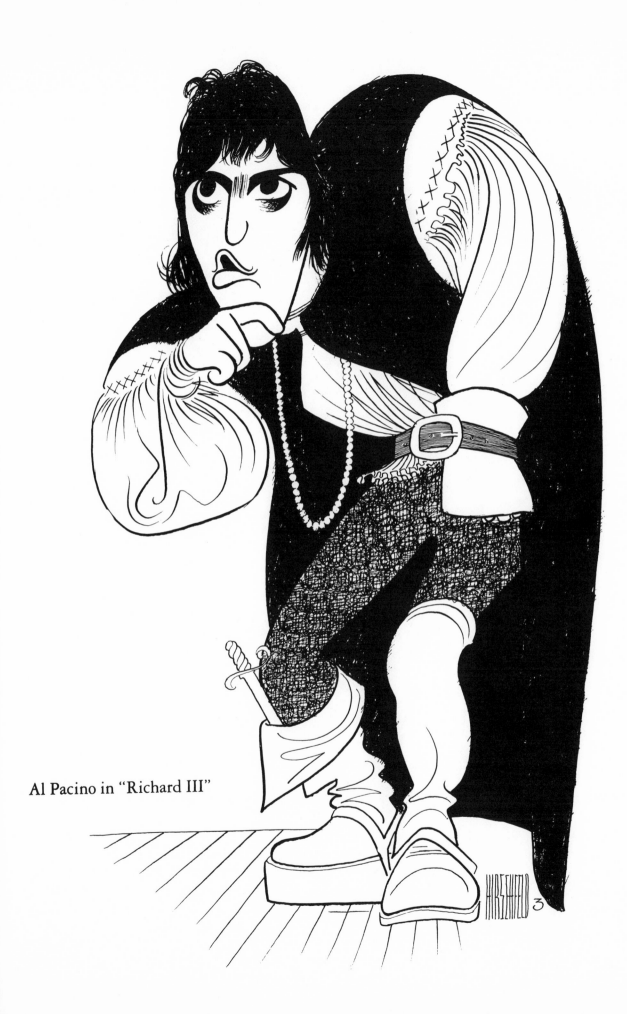

Al Pacino in "Richard III"

Ellis Rabb

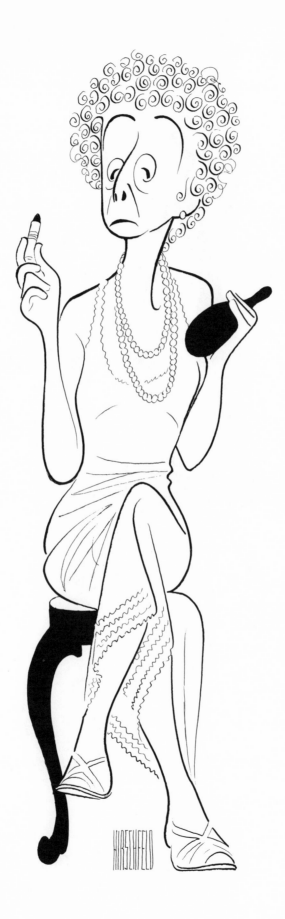

Joan Hickson
in "Bedroom Farce"

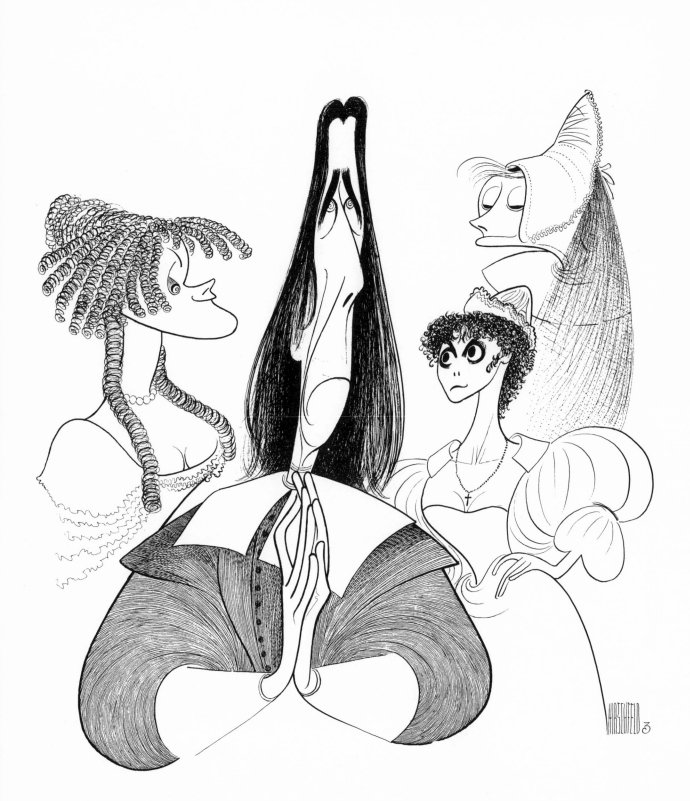

Tammy Grimes, John Wood, Patricia Elliott and Mildred Dunnock in "Tartuffe"

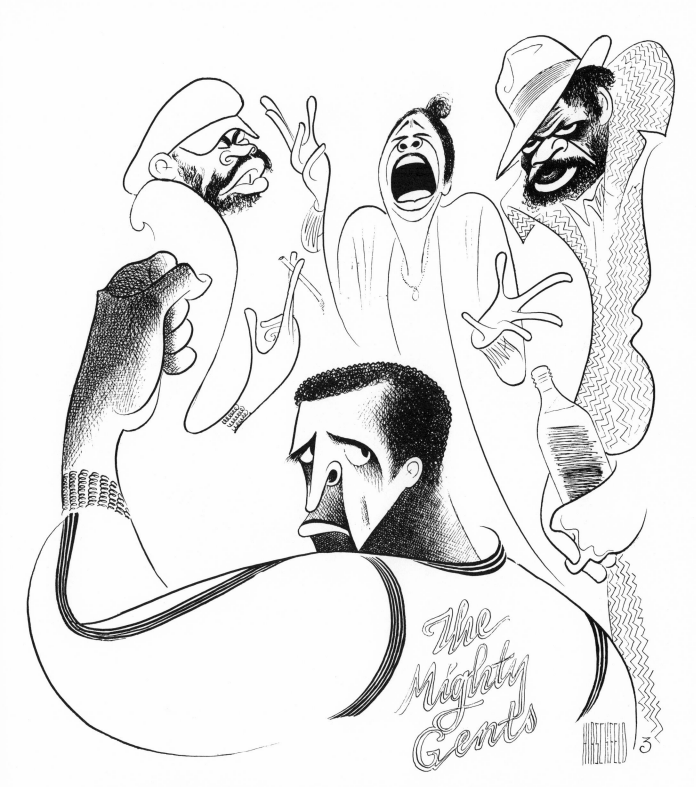

Richard Gant, Dorian Harewood, Starletta Du Pois and Morgan Freeman
in "The Mighty Gents"

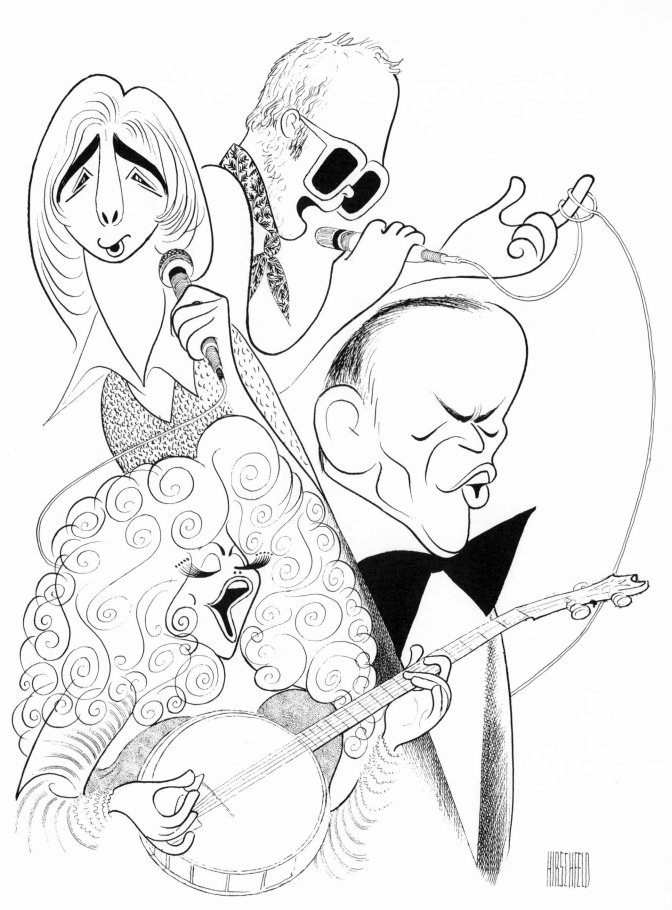

Dolly Parton, Barry Manilow, Elton John and Frank Sinatra

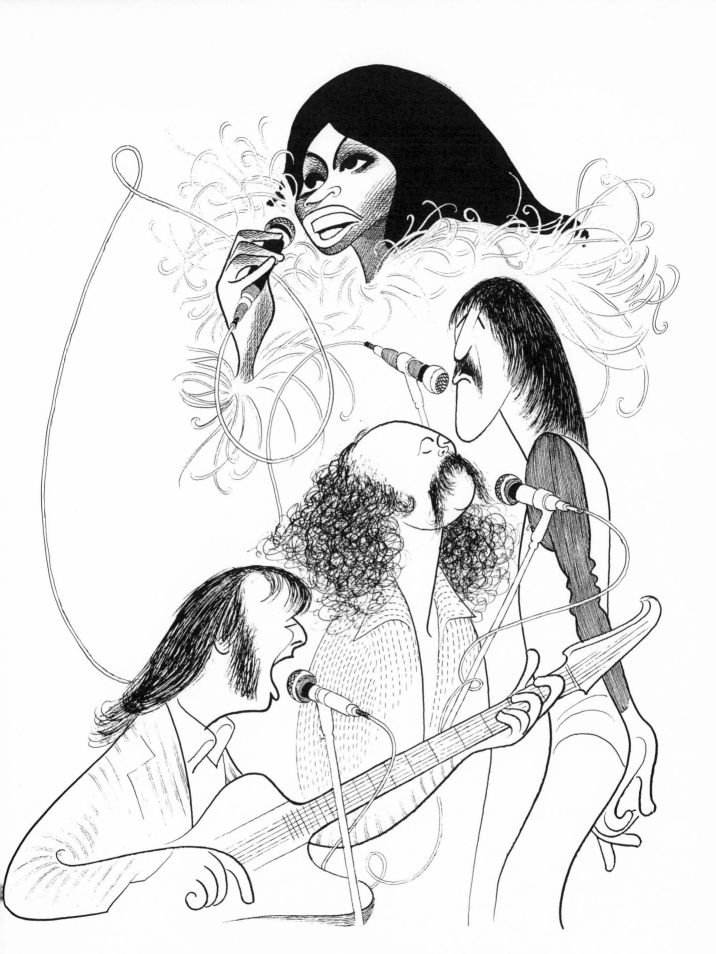

Diana Ross, Graham Nash, Stephen Stills and David Crosby

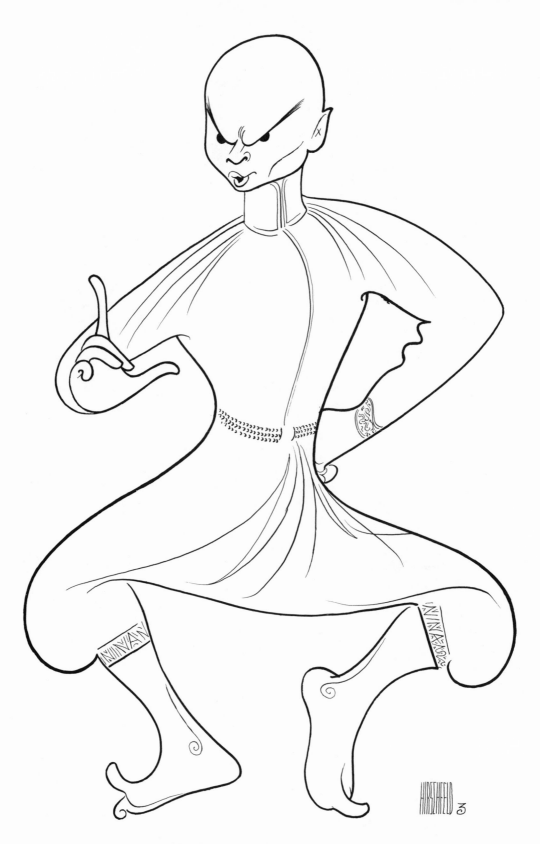

Yul Brynner in "The King and I"

Index